PAINTING STILL LIFES STEP BY STEP

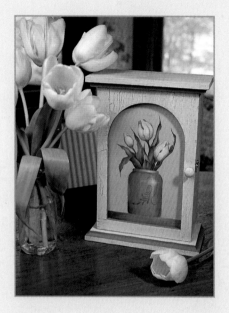

Mary McLean, CDA

NORTH LIGHT BOOKS

CINCINNATI, OHIO
www.artistsnetwork.com

METRIC CONVERSION CHART

TO CONVERT	TO	MULTIPLY BY
Inches	Centimeters	2.54
Centimeters	Inches	0.4
Feet	Centimeters	30.5
Centimeters	Feet	0.03
Yards	Meters	0.9
Meters	Yards	1.1
Sq. Inches	Sq. Centimeters	6.45
Sq. Centimeters	Sq. Inches	0.16
Sq. Feet	Sq. Meters	0.09
Sq. Meters	Sq. Feet	10.8
Sq. Yards	Sq. Meters	0.8
Sq. Meters	Sq. Yards	1.2
Pounds	Kilograms	0.45
Kilograms	Pounds	2.2
Ounces	Grams	28.4
Grams	Ounces	0.04

About the Author

Mary McLean grew up as an only child in a small New England community on Cape Cod, Massachusetts. The natural beauty of this rural upbringing was a strong influence on her creative development.

She received a B.F.A. and a M.Ed. in art education and taught art in a small suburb of Boston. In 1982, she took a decorative painting class to paint a welcome slate for her home. Six weeks later, she was teaching friends at a card table how to paint strawberries and daisies. Mary joined the National Society of Decorative Painters in 1983, and in 1991, she received her certified decorative artist award at the national convention in Salt Lake City, Utah.

Mary teaches in her home studio, at national conventions, and accepts teaching assignments throughout the United States. She is the author of more than fifty pattern packets. She has written a series of four books, entitled *Celebrations of Beauty*, and has published articles in several decorative painting magazines including *Decorative Artist's Workbook* and *The Decorative Painter*.

Other fine North Light Books are available from your local bookstore, art supply store or direct from the publisher.

07 06 05 04 03 5 4 3 2 1

Library of Congress Cataloging-in-Publication Data

McLean, Mary
 Painting still lifes: step by step / Mary McLean.
 p. cm.
 Includes index.
 ISBN 1-58180-299-4
 1. Still-life painting—Technique. I. Title.
ND1390 .M376 2003
751.45'435—dc21 2002070150

Editor: Christine Doyle
Production Coordinator: Kristen D. Heller
Designer: Joanna Detz
Layout Artist: Joni DeLuca
Photographer: Christine Polomsky and Tim Grondin

Acknowledgments

The journey to any destination can be a path to enlightenment. The road may be long and winding, with many crossroads along the way. There are hills that must be climbed and streams to be crossed. The hills may become mountains and the streams become rivers, but the journey moves on.

During the trip, the traveler may discover that the power to continue lies within. Perseverance, curiosity and appreciation must be constant companions. The determination to move on, the willingness to take risks, and the acknowledgment of the past will bring the destination closer and closer. Savor the moments of discovery and build upon them for the future. Share the moments with others and the road will become much clearer.

The traveler is no longer alone, but surrounded by the companions of Light and Beauty. Soon, they are joined by Experience, Wisdom and Inspiration. These friends will always enrich the journey. Build on these friendships and celebrate their wonder. The destination may be within sight, or you may have to travel just a bit longer. Look for the rainbows and move on. The road continues just over the next hill.

To those who have shared my journey, I rejoice that we have touched each other's heart. You have given me strength and joy and the motivation to move on. You are my family, my friends, my acquaintances, my students, my teachers and countless others whose names and faces I do not know.

You are my power within. I treasure your generosity and support. You are the rainbow as I continue on down the road.

Dedication

This book is dedicated to my family:

To my husband, David...for your love and support, I owe you everything.

To my daughters, Tracey, Tara and Leah...my friends, growing more beautiful every day.

To my grandchildren, David and Jenna...the cycle of life and a glimpse into the future.

*To my sons-in-law, Frank * and Paul...my sons of the heart.*

To my mother, Kathleen.... a simple crayon can make all the difference.

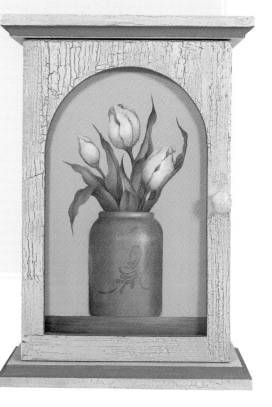

Table of Contents

Introduction, 7

chapter 1

Materials and Preparation, 8

chapter 2

Basics of Realism, 16

chapter 3

Mixed Media Technique, 20

Project 1

Provincial Elegance, 22

Project 2

A Time to Enjoy, 36

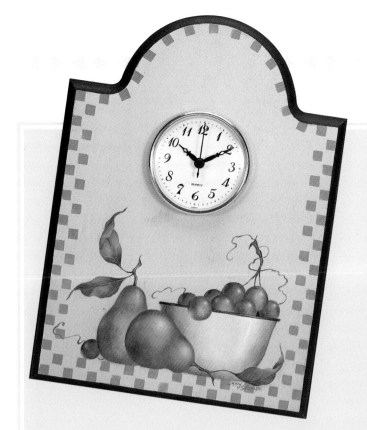

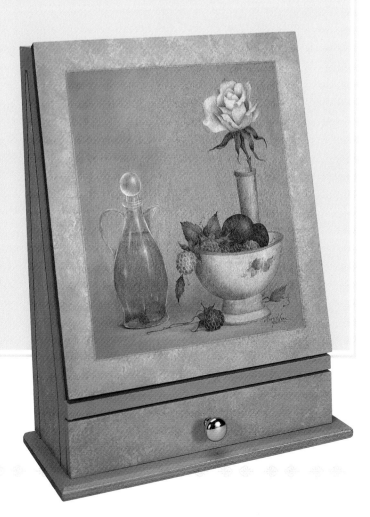

Introduction

As an avid antiques enthusiast, I continue to search for interesting objects to display in my home. Over the years, the collections have grown and available space seems to diminish after each shopping spree. Groupings are everywhere. I have filled the shelves, tabletops, cabinets and nooks with an assemblage of items from another time.

There are groups of tins, graniteware, baskets, crocks, boxes and glassware. Their individual stories have become part of my everyday world. Sometimes they are shown together, sometimes as part of another ever-changing display. I enjoy their variety of color, shape and texture. Their fascination lies in the fact that their impression changes as I move them about the house.

As I place my antiques into a pleasing arrangement, I find that I am actually composing a still life painting. The definition of a still life is explained as a pictorial representation of inanimate objects. It is one of the most popular genres of art because the viewer can immediately identify on some level with the visual display. Groupings of fruits, flowers, fabrics and containers from everyday life are a common occurrence. Familiar arrangements create a comfort zone for those who view this type of painting. If the viewers can relate to the subject matter, they will continue to savor the painting with joy and wonder.

When I begin to plan a new still life painting, composition is the most important element to consider. A pleasing arrangement of objects will capture the viewer's eye. Creating still life compositions is one of the easiest ways to learn to paint realistically. What is realism? It is the depiction of exactly what you see in front of you. It is giving viewers the impression that they can experience what you the artist have observed. Therefore, artists must learn to see what is in front of them.

Relating objects to basic natural forms can enhance observation skills. There are four basic natural forms: the cylinder, the sphere, the cone and the cube. If we look closely, most objects are composed of one or more of these shapes. Crocks may be cylinders, grapes are spheres, bottles could be cones, and books are cubes. Once we begin to see and relate these shapes, realistic interpretation is enhanced.

Next, it is necessary to develop a light source that will remain consistent throughout the painting. Each object in the composition must receive light from the same origin. Finally, color harmony will ensure a pleasing visual effect. The relationship and repetition of color throughout the painting will likely provoke a positive viewer response.

Other elements to be considered when trying to present a realistic rendition of objects are good draftsmanship, a balance of variety and detail, consistent viewpoint, and the development of a focal area. As you work your way through the projects in this book, keep these concepts in mind. Through practice, the concept of reality is within your grasp.

And so I continue my search for just one more antique to place in my next still life design. Is it the hunt or the result that is the most important? The search is stimulating and creative, but a new acquisition may provide inspiration and enlightenment. To me, each is important. I enjoy both the process and the product.

By the way, a new little shop just opened in a neighboring town. It is just a short trip. I think I will drop in. Are you ready for a new adventure? Would you like to join me?

Mary McLean, CDA

1

Materials and Preparation

Studio Set-up

Any artistic endeavor is a product of much planning and arrangement. Take great care to allow a welcoming and creative workspace to evolve in your studio area. The creative process needs no distractions. With such an environment, moving from idea to finished product will become a much easier process. When painting in my studio, I make a great effort to place myself in the best possible position to make visual assessments about color interactions. This arrangement may change from time to time. Change is good. I find that natural light helps me to determine the value and intensities of my colors. As a result, my painting table and a comfortable chair are located close to a window.

I like to enhance the natural light with the addition of a painting lamp that will simulate natural lighting. There are several brands in the marketplace. My lamp contains both a warm incandescent bulb and a round cool fluorescent fixture. I supplement this lighting with a ceiling light that contains both a warm and cool fluorescent fixture. No matter what the day, I am always in control of the lighting situation and am able to see my colors in the simulated natural light.

When setting up my painting area, I have tried to organize the workspace for maximum efficiency. I like to channel my energy into the painting and not into looking for materials. I use an assortment of plastic shelves, drawers and baskets to keep supplies close at hand. When a painting session is completed, I try to clean up right away and return supplies to their designated area. Then I am ready to create on another day.

Listed on the following pages are my favorite paints, brushes and general supplies that I have used in this book.

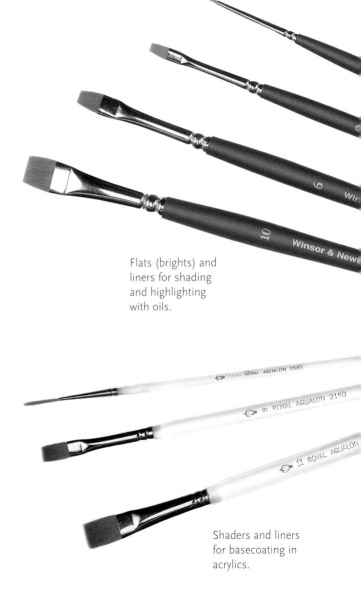

Flats (brights) and liners for shading and highlighting with oils.

Shaders and liners for basecoating in acrylics.

Brushes

Brushes are always an expensive investment. When cleaning your brushes, take great care to maintain their original shape. When painting with more than one media, I recommend that you maintain a separate set of brushes for each one.

Acrylic Brushes

Acrylic artists use a longer haired, flat brush because it must hold an adequate amount of both water and acrylic paint. My choice for acrylic brushes is the Aqualon Shader, series 2150, by Royal Brush. They hold a significant load of paint and water and splay apart to create a wonderful graduated float.

Fully clean the brush in the brush basin quite frequently. Acrylic paint slips in near the metal ferrule of the brush and can dry quickly. When cleaning acrylic paint from a brush:

1. Pull the brush in one direction along the raised bottom ridges of the brush tub. I prefer to pull toward me.

2. Turn the brush over and repeat the action to the other side.

3. Tap the side of the brush with pressure on a paper towel to check for residue. Repeat the action if necessary.

4. When doing a final cleaning, rinse in a brush cleaner, such as DecoArt Brush Magic, and form into original shape. Store in an upright container.

Oil Brushes

Oil artists tend to use a short flat brush to minimize the play of fibers during the blending process. When painting with oils, I use a short, flat bright, series 510, from Winsor & Newton. Its synthetic filament maintains a sharp, crisp edge.

When cleaning oil paint from the brush:

1. Hold the brush in a perpendicular position and squeeze the excess paint from it with a paper towel. Pull from the metal ferrule to the end of the brush fibers.

2. Rinse the brush in solvent, pulling the brush in one direction. Turn the brush over and rinse the other side.

3. Tap on a paper towel with pressure. If paint residue is evident, repeat the process.

4. If the brush still appears to contain paint, pour a little Brush Magic into a bottle cap and repeat the rinsing process. Rinse one side, then the other, then tap the brush on a paper towel.

5. Ease all fibers back into their original position and store in an upright container. Hint: Have you tried storing your brushes in a drinking straw container?

Mop Brushes

When choosing a mop, I prefer Ann Kingslan Mops. They have short, dense natural hair fibers that respond to repeated pouncing techniques. When painting or cleaning these brushes, it is natural that some hairs will release onto the surface. Hint: I keep a sewing needle in a piece of Styrofoam nearby. Pick the hair up with the needle, then replace the needle into the Styrofoam.

When cleaning oil paint from a mop:

1. Process as indicated with the flat brushes.

2. When the brush appears to be clean, fluff the fibers to maintain the shape and store in an upright position, bristles up.

Additional Brushes

Other brushes that will be helpful are stencil brushes, liner brushes (for both acrylics and oils), old splayed brushes and stiff-bristled fabric brushes. Clean these brushes as indicated by medium.

Mop brushes for softening shading and highlighting.

Paints

Acrylic Palette

I use DecoArt Americana acrylics for the background and for basecoating each element. They provide a wide color range and opaque covering ability. When setting up my palette, I place a dampened paper towel at the top of the palette. I then place my acrylics on the dampened towel. They will remain workable for a long period of time and will not skim over. When basecoating is completed, simply lift up the towel and throw it away. I learned this process in one of my first seminars with Jo Sonja Jansen.

Basic Oil Palette

Winton Oils by Winsor & Newton
Winton Oils are a student grade oil paint that contains less pigment than Winsor & Newton's artist oils. This transparency is perfect for the mixed media glazing technique. The colors that were used in this book are shown below.

Shiva Permasol Oil
Shiva Permasol oil paints are extremely weak in pigment with a full-bodied consistency. These transparent oil paints are just great for glazing techniques. The paints can be purchased from art supply distributors such as Hofcraft and Quarry House (see resources on page 126).

The Shiva Permasol colors that were used in this book are Black (referred to in the book as Permasol Black) and Golden Ochre. See the chart below.

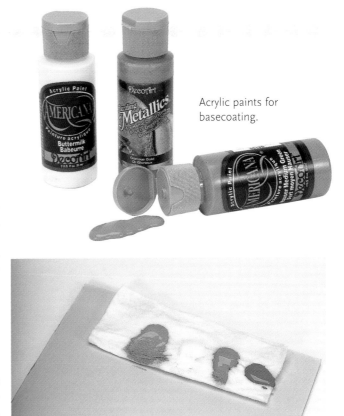

Acrylic paints for basecoating.

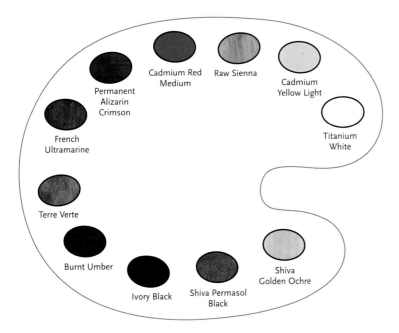

Place acrylic paints on a wet paper towel on your palette to keep them from skimming over.

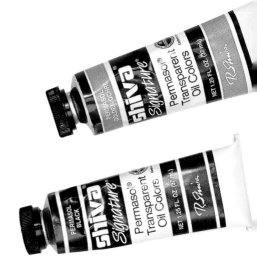

Oil paints for shading and highlighting.

Permanent Alizarin Crimson

Cadmium Red Medium

Raw Sienna

Cadmium Yellow Light

French Ultramarine

Titanium White

Terre Verte

Burnt Umber

Ivory Black

Shiva Permasol Black

Shiva Golden Ochre

General Supplies

- sanding discs in various grits

- tack cloth to remove excess dust from a sanded surface. (Hint: Keep your cloth wrapped in a recloseable sandwich bag.)

- Straight From the Heart wood sealer: a traditional wood sealer that seals the wood grain and prevents any bleed-through to the acrylic basecoat.

- small sponge roller, which can be obtained at your local hardware department

- tracing paper

- gray and white transfer paper

- sharp pencil to trace patterns

- eraser to make corrections on the traced pattern

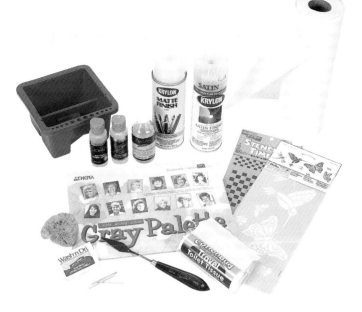

Clockwise from top left: water basin, brush cleaner, crackling medium, thinner for oil paints, spray varnish, paper towels, stencils, toilet tissue, palette paper, palette knife, cotton swabs, wet towelettes, sea sponge.

- stylus

- clear plastic ruler

- easy-release tape that will not pick off undercoats: I use Scotch Magic Tape.

- sea sponge to create mottled faux effects

- water basin

- cotton swabs to correct mistakes

- wet towelettes to clean paint from hands and surfaces

- gray palette pad: The gray pad allows me to make a better visual color assessment.

- palette knife

- paper towels

- Archival Odourless Solvent: an extremely low-odor refined thinner for oil paints.

- DecoArt Brush Magic: a wonderful water-based product to clean brushes.

- DecoArt Weathered Wood: When applied according to directions, this product creates medium to large cracks in the paint.

- Krylon Matte Finish 1311: an aid used to quick-dry a wet finish. It is not a final varnish.

- Krylon Satin Varnish: a final protective varnish. Follow the label instructions. It is best to use the same brand as any previous spray that has been used on the surface. I will usually apply two to three coats, timing them according to the manufacturer's instructions.

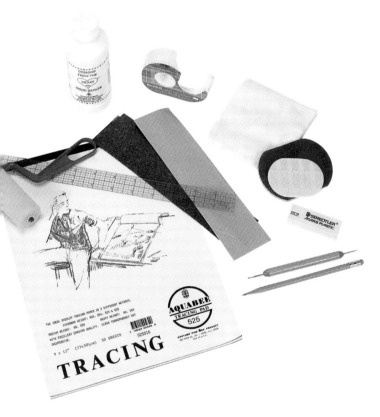

Clockwise from top left: wood sealer, easy-release tape, tack cloth, sanding discs, eraser, stylus, pencil, transfer paper, clear plastic ruler, sponge roller and tracing paper.

Surface Preparation

The key to an attractive project is to carefully prepare and finish the surface on which you will place the design. I use my sense of touch to assess and complete the preparation and finishing of the piece. First, I examine the surface for any blemishes or imperfections. Then I lightly scan the surface with the edges of my fingertips to find any areas that may not show up in a visual assessment. Finally, I prepare the surface as shown in the following steps.

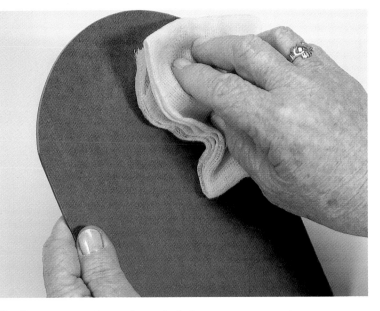

[2] Wipe the surface with a tack cloth to remove excess dust.

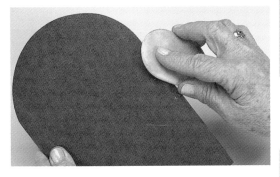

[1] To prepare the masonite panel, sand the edges with a sanding disc.

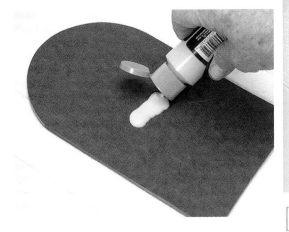

[3] Shake the bottle of basecoat color and apply a small amount directly on the surface.

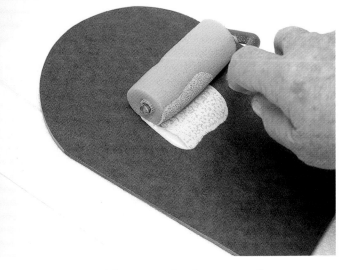

[4] With pressure, spread the paint with a dry sponge roller.

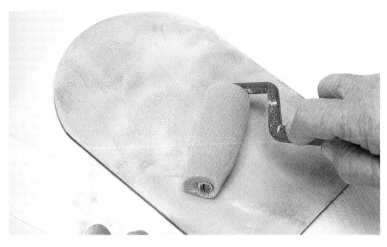

[5] Continue to spread the paint in different directions. Lighten the pressure on the roller until the paint sheen dulls to a matte application. This will be a transparent application.

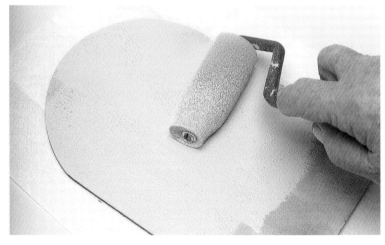

[6] Dry the surface thoroughly. You'll know the surface is dry when it feels room temperature. If it feels cool, it may be dry to the touch, but it's not yet thoroughly dry. Wipe the surface with an extra fine sanding disc and remove any dust with a tack cloth. Place more paint on the surface and again, move it out using the sponge roller. As the surface begins to indicate a matte sheen, apply less pressure. Bubbles may form, but the lighter pressure will break the bubbles and provide a smooth surface.

HINT

WHEN WAITING FOR THE FIRST COAT TO DRY, WRAP THE SPONGE ROLLER IN A DAMP PAPER TOWEL. DO NOT RINSE IN WATER UNTIL THE SURFACE PREPARATION HAS BEEN COMPLETED.

Preparing Wood

[1] To prepare a wooden surface, sand in the direction of the grain and wipe with a tack cloth, as with the masonite surface. Then seal with wood sealer using a foam brush.

[2] This application will raise the grain slightly, so let dry, then sand again. Continue with the basecoating as directed in step 3 on page 12, painting in the direction of the grain.

Surface Preparation, *continued*

[7] Two coats should give you good opaque coverage, but if you feel you need a third coat, wait ten minutes to allow the paint to cure before beginning the third coat. The goal for the surface preparation is to present an eggshell sheen.

HINT

A SURFACE MAY BE DRY TO THE
TOUCH, BUT MAY NOT BE
CURED. IF YOU TRANSFER
THE PATTERN ONTO A DAMP
SURFACE, IT COULD CURE
IN THE PATTERN TRANSFER
LINES. SOMETIMES THIS MAKES
IT DIFFICULT TO REMOVE
UNWANTED TRANSFER LINES.
A CURED SURFACE WILL BE
ROOM TEMPERATURE.

Tracing the Pattern

[1] Trace the pattern from a photocopy using a pencil and tracing paper.

[2] In realistic painting, we need to prove the graphics of the design to ensure that the containers are symmetrically balanced. To do this, fold the traced pattern in half with pencil sides on the outside. Check that the lines for the sides of the containers overlap.

[3] If they don't, erase one side.

[4] Then redraw that side to match the other side of the container.

[5] Before you begin, also check to make sure the container is perpendicular to the table. For this project (project 1 on page 22), place the horizontal line of the ruler on the shelf line. The vertical line edge of the crock should align with one of the vertical lines on the ruler. If not, make the correction.

[6] Next, check that any horizontal lines are perpendicular to the vertical lines. In this pattern, the top of the crock should be perpendicular to the side of the crock.

Transfer the pattern to the surface (see page 26 for detailed instruction on pattern transfer) and paint according to the project instructions.

Finishing

When applying the finish to a painting, have patience with the application. When choosing a varnish, look for compatibility with the paint medium that you have chosen to use. A water-based varnish should not be used with oil paints. My varnish of choice is Krylon Satin Varnish. It provides a low-luster sheen to the surface of the painting and enhances the glow of the oil paints. Following the directions on the can, apply the final varnish in a well-ventilated area. I prefer to spray outside on a sunny day.

Before varnishing, make sure the surface is sufficiently dry. Using a tack rag, wipe off any dust. In an adequately ventilated area, shake the varnish can vigorously. Apply one light, even coat to the surface. Following the directions on the can, apply several more coats to the surface. Let the surface dry adequately between applications.

HINT

IF YOU WOULD LIKE AN EXTRA PROTECTED WAX SURFACE, APPLY A COAT OF NATURAL SHOE POLISH AND BUFF WITH A SOFT CLOTH.

Basics of Realism

Realism is the representation of objects as they appear in life. With skill and inspiration, the objects in a painting can appear to be dimensional. These representations are often so visually intriguing that the viewer may come back to observe them again and again. The portrayal charms observers, allowing them to appreciate the skill and presentation. Many times, the artist will use this means of attraction to encourage the viewer to linger within the painting and savor its beauty. Realism can bring drama and intrigue to any work of art.

The art of still life painting offers a wonderful opportunity to depict the basics of realism. A still life is an arrangement of both inanimate and animate objects. If these objects project the feeling of reality, the viewer will enter the painting to explore its unique qualities. In order to create this reaction, the artist must understand naturally occurring forms as well as the effect of light on these shapes.

Form

One of the basic components of any realistic interpretation is form. Form is the determined shape of any object. Good form creates reality. When painting a still life, creating the form of each object is the primary goal of the artist. There are four basic natural shapes or forms: the cylinder, the sphere, the cone and the cube.

The cylinder is a rounded surface with parallel lines. When viewed from above or below eye-level perspective, the top and

base become similar curved ellipses. A cylinder may exist by itself or in combination with other forms. Typical cylinders are crocks, cups, vases, tins and bottles.

The sphere is a round, circular shape. It occurs quite frequently in both full and partial form. Balls, grapes, knobs, vases, marbles, snowmen and balloons are examples of spherical forms. Some objects, such as cups and bowls, are composed of a part of the sphere.

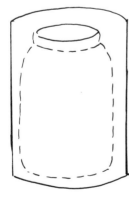

A crock can take the form of a cylinder.

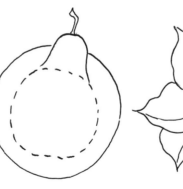

A pear can take the form of a sphere.

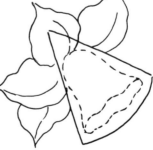

A daffodil can take the form of a cone.

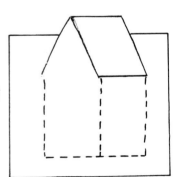

A house can take the form of a cube.

The cone is a solid form that evenly slopes to a point from a circular base. It is visually present in many everyday objects, one of the most obvious being an ice cream cone. But many bottles and containers are cones, just not in their entire form. Most often the shape stops short of the cone's point and merges into an adjoining form.

A cube is a solid surface that has six faces: a top, bottom, and four sides. These sides may not be the same size as the top or bottom, but their vertical edge will relate to the plane on which they rest. Often we observe the cube form in boxes, books, tins, baskets and shelves. These forms will vary in position and size.

Many objects take on just one of the simplistic natural forms; for example, apples, grapes and raspberries resemble a sphere. Other objects may be made up of multiple natural forms: for example, the bottom of a pear is a sphere, while the top is sometimes a cylinder or a cone. The first step to creating reality is to identify the form of each object in the composition.

Value and Viewing Perspective

Once the form is identified, an artist can enhance the form by giving the object values. Value is the lightness or darkness of a color. Value change within an object will create form.

Each unit in the composition must contain a minimum of three values; light, medium and dark. The light value will indicate the light source, the medium value will disclose the mass color of the object, and the dark will show the area most distant from the origin of light.

Once the forms are identified, it is important to consider the viewing perspective and source of light. When observing a still life, the viewer is most comfortable with one established viewing perspective and one light source. A composition can be positioned at eye level, below eye level or above eye level.

Eye-level perspective is visually pleasing and allows the viewer to enter the painting to concentrate on the grouping itself. Technically, it presents fewer challenges, allowing the artist to concentrate on effect and not on the more difficult concept of drawing in perspective.

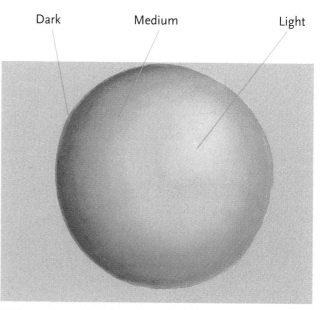

Dark Medium Light

Without values, this ball would just look like a circle. It's the light, medium and dark values that make it look rounded.

Eye-level perspective

Below eye-level perspective

Above eye-level perspective

Viewing Perspective, *continued*

Below eye-level perspective is also pleasing to the viewer. It is the viewpoint from which we see most everyday objects—the objects are below us so we look down at them. Therefore, it is a comfortable observation point to invite the viewer to enter a composition. The drawing challenges increase for the tops of each item. Ellipses become evident, values change, and cast shadows become more important.

Above eye-level perspective presents the least comfortable observation point for the viewer. It is unfamiliar, unusual and visually jarring. The artist must capitalize on this effect and employ such a reaction to entice the viewer to remain in the painting. Keeping the perspective true for all objects will help to establish a visual comfort zone.

Light Source

Next, it is important to establish the direction of the light source. This may be a center, a left-hand, or a right-hand light source. Light must affect all objects in the composition in the same way. The light source will determine where the highlights and shading fall. The highlights are placed where the light hits the object, and shading is placed at the points farthest from the light source.

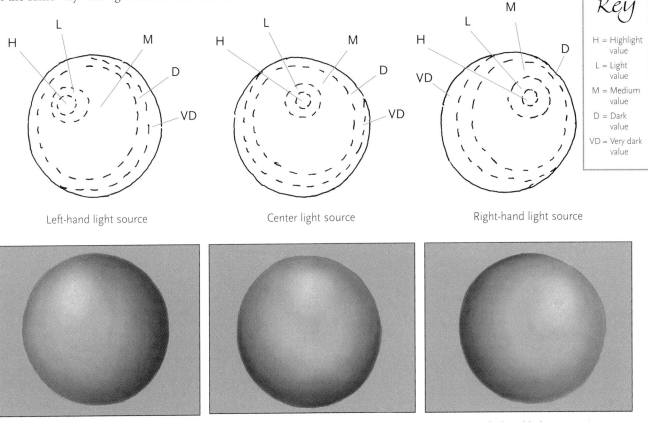

H = Highlight value
L = Light value
M = Medium value
D = Dark value
VD = Very dark value

Left-hand light source Center light source Right-hand light source

Left-hand light source Center light source Right-hand light source

The illustrations show how the location of the light source affects the placement of the values on a sphere. The area where the light first hits the object is the highlight area. As the light disperses around the sphere, the values get darker. The darkest value is placed in the area furthest from the highlight area.

The top row of images illustrates where each value is placed depending on the location of the light source. In the bottom row, these spheres have been painted with a smooth gradation of values.

Details

The final element to consider when painting realistically is detail. The details, especially unexpected ones, can add dramatic impact to a painting. A dewdrop resting on an apple or a small bug bite out of a leaf are the things that make a painting seem alive. But be careful not to overwhelm a painting with details. These elements aren't the focus of the painting; they simply provide a point of fascination and wonder.

In the projects that are presented in this book, you will learn to identify various shapes and how they may exist in relationship to a predetermined light source. We will explore the viewing perspective of above- and below-eye-level presentation. As we progress through the projects, we will discover the importance of other aspects that enhance the effect. The details that add to the feeling of reality are dewdrops, cast shadows and color temperature (see below). Color values and the development of a focal area will also be considered as keys to the creation of reality.

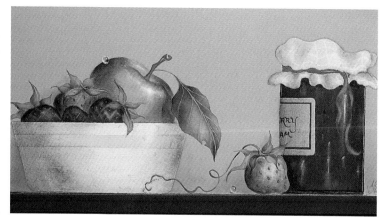

It's the detail in this scene—the dewdrops, the bug bite on the leaf—that really brings it to life.

Temperature

The temperature of the colors you use in your painting enhances its visual appeal as well. A balance of warm and cool colors gives position and depth to the painting. Red, orange and yellow are warm colors; blue, violet and green are cool colors. In general, warm colors advance and cool colors recede. But the color temperature of the background governs the visual effect of the color interaction. The element that has the opposite temperature of the background will advance. Elements that are the same temperature of the background will recede.

In the illustration at right, a warm and a cool leaf are painted on each background. The warm leaf advances on the cool gray background, and the cool leaf advances on the warm yellow.

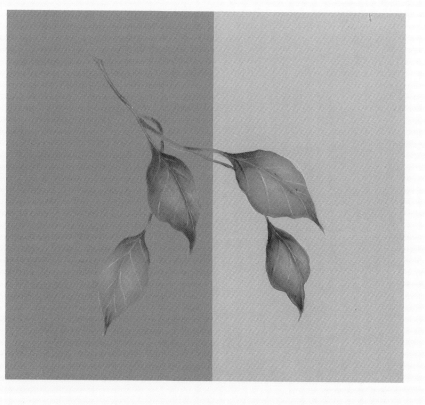

Mixed Media Technique

When painting a still life composition, I love to use multiple media materials. A mixed media technique involves the use of more than one medium to create form, harmony and interest within a painting. The application of more than one medium in a project can create visual excitement for the viewer as well. Possible products to be considered are oils, acrylics, watercolor, gouache, ink and collage.

Each product has specific advantages and disadvantages. When considering which to employ, weigh the positive and negatives of each medium. For example, when using the combination of acrylics and oils, consider the chart below.

Acrylics and Oils: Advantages and Disadvantages

The advantages of acrylics
- dry quickly for multiple undercoats
- provide opaque coverage
- present a low color intensity
- have a wide choice of pre-made colors

The disadvantages of acrylics
- quick drying time does not allow open time to create a blended effect
- opaqueness means that you must add water to make them transparent
- not very bright in intensity and do not provide a glowing color
- wide variety of pre-made colors does not promote the instinct to mix hues for color spontaneity

The advantages of oils
- dry slowly to allow the artist to create a desired effect
- transparent, which allows the artist to effectively adjust values, add color accents, and to change temperatures
- have a high visual color intensity

The disadvantages of oil paints
- dry slowly and at different rates. As a result, other techniques must be employed to speed up the drying time, such as adding a drying agent or spray drying with Krylon Matte Finish 1311.
- high intensity means you must mix other colors into the base color to make it less bright

Using Acrylics and Oils to Create Realism

As was discussed in the previous chapter, creating value is essential to creating form, which is an integral part of realism. Mixed media is an interesting way to create a strong value change in order to present a realistic form. Considering the advantages and disadvantages of the various products, an ideal approach is to use a combination of acrylics and oils. Acrylics are a perfect choice for establishing the base hue of each object. They present a wide variety of color choices, cover opaquely and dry quickly. Oils are wonderful to complete the forms by adding dark and light values. They allow sufficient open time to graduate the value changes, are transparent to let the undercoat show through, and offer a high intensity of color to bring a glow to the formed image.

When I paint my still lifes I like to fill in the basic forms with opaque acrylics to establish the medium value. They dry quickly and I am ready to move on. Later, I enhance the forms with oils to create a vibrant presentation. The oils leave open time to create the dramatic value changes for a realistic image. Following is a brief overview of the procedure for creating still lifes in this way. (Colors, placement and more specific techniques are included with each project in this book.)

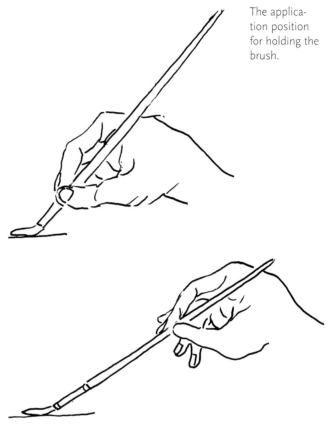

The application position for holding the brush.

The blending position for holding the brush.

Painting the Medium Value

In this method of painting, the surface is prepared as described on pages 12-15. Then each individual object in the composition is painted with acrylic paint. This is the medium value of the form to be painted—shading and highlights will be added later. Keep in mind that in relationship to the background, similar values will recede and dissimilar values will advance. Using the appropriate-size brush, basecoat each element with the relevant acrylic color (a chart is provided for each project in this book). These applications should be smooth and opaque without any ridges. Transfer details of the pattern to the surface and paint with acrylic color. To seal the acrylic basecoats, lightly spray the surface with Krylon Matte Finish 1311.

Painting the Dark Value

Next establish the dark values of each object in the composition with oil paints. This value along with the medium-value basecoat will create basic form. Using the appropriate-size brush, apply a sparse amount of oil paint in the dark area of the object (colors and placement are given in each project). Hold the brush in the application position (see illustration above), grasping it near the metal ferrule. This application will cover the entire dark area. Then move your grasp of the brush further up the handle to the blending position. Using the flat side of the brush, soften the gradation of color. With a mop, blend any hard edges into the base color.

Painting the Light Value

Using a sparse amount of paint, establish the light values on each object in the composition. Grasping the brush in the application position, apply the indicated color in the specified area. Move your grasp of the brush further up the handle to the blending position. Using the side of the brush, soften the gradation of color. Then blend any hard edges into the base color with a mop. The three values—medium, dark and light— will create dimensional form.

Painting Additional Values

In addition to the three basic values, you can create value change within the dark and light areas. Five values create the most realistic form. So reinforce the darkest of the dark values and the lightest of the light areas. Add tints and accents to carry certain colors throughout the composition, and create value change within the tint and accent areas as well. Blend this color into the base with a mop brush.

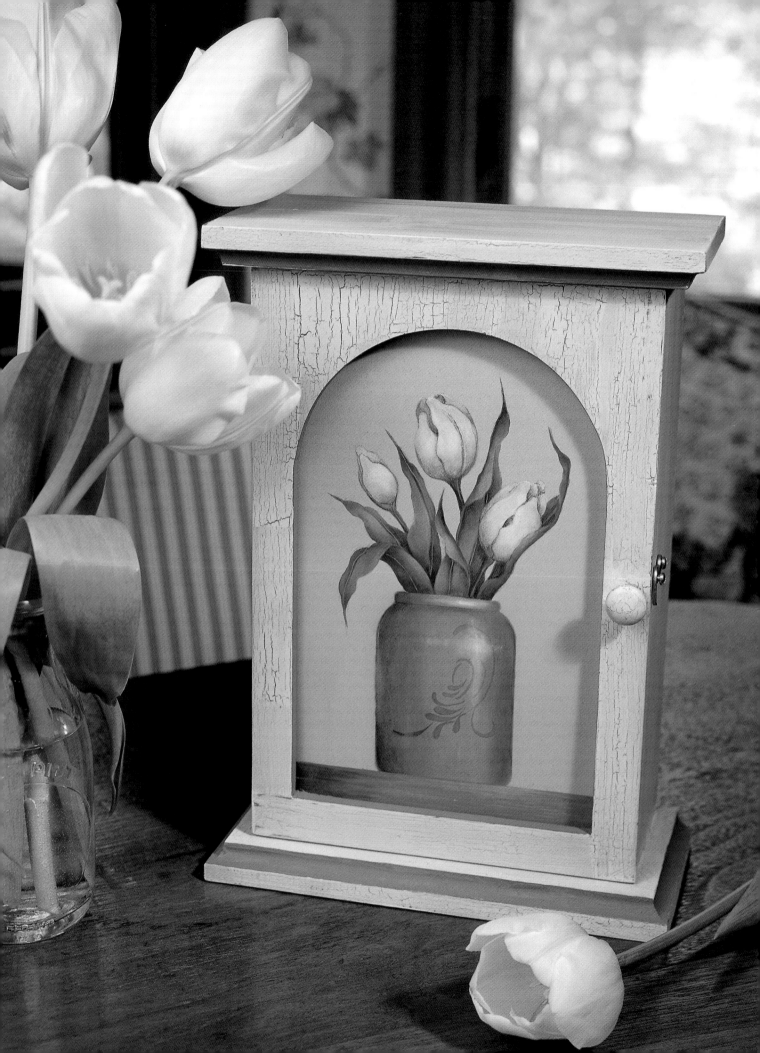

1

Provincial Elegance

The crock in this project can be identified as a cylinder,
and the light source is emanating from an upper right hand position. You can
enhance a realistic portrayal of any container by establishing a predominant light
source. The lightest part of the cylinder will be the area of the form that is closest
to the origin of light. The darker part of the cylinder will exist at the point that
is furthest away from the light. Three values will create basic form, but the use
of five values will increase the perception of reality.

Paints

DecoArt Americana Acrylic Paints

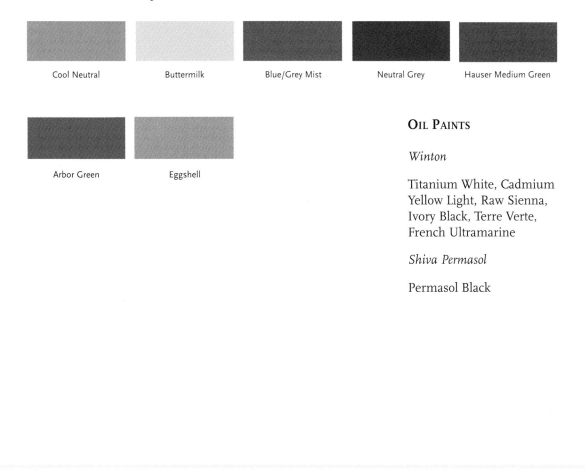

| Cool Neutral | Buttermilk | Blue/Grey Mist | Neutral Grey | Hauser Medium Green |

| Arbor Green | Eggshell |

OIL PAINTS

Winton

Titanium White, Cadmium
Yellow Light, Raw Sienna,
Ivory Black, Terre Verte,
French Ultramarine

Shiva Permasol

Permasol Black

Pattern and Materials

Materials

BRUSHES

- Royal Brush Aqualon Series 2150 nos. 4, 8 and 10 flats

- Royal Brush Aqualon Series 2585 no. 10/0 liner

- Winsor & Newton Series 510 nos. 0, 2, 4, 6, 8 and 12 flats

- Winsor & Newton Series 540 no. 10/0 liner

- Ann Kingslan mops nos. 0 and 1

ADDITIONAL SUPPLIES

Sanding disc, tack cloth, wood sealer, sponge brush, sponge roller, pencil, tracing paper, gray transfer paper, stylus, gray palette, DecoArt Weathered Wood, Archival Odourless Solvent, Krylon Matte Finish 1311, clear plastic ruler, easy-release tape, paper towel

SURFACE

- Small arch cabinet from Bush's Smoky Mountain Wood Products

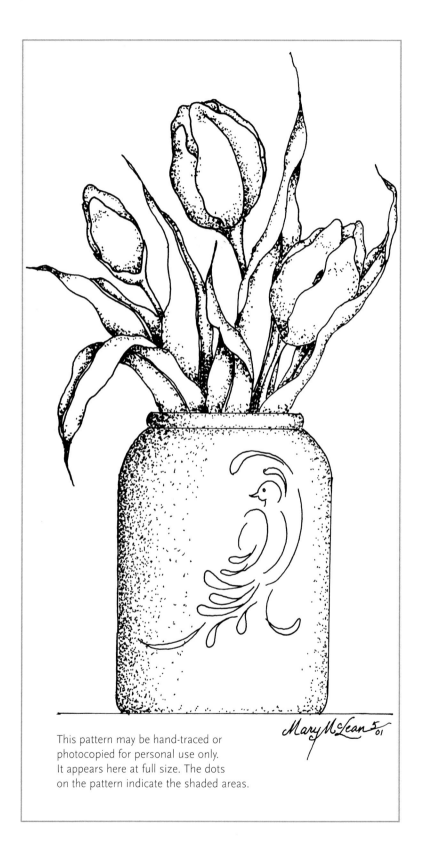

This pattern may be hand-traced or photocopied for personal use only. It appears here at full size. The dots on the pattern indicate the shaded areas.

Acrylic Conversion Chart

If you choose to paint this project entirely with acrylics, consider the following conversions using DecoArt Americana Acrylics.

OBJECT	BASECOAT	LIGHT	HIGHLIGHT	DARK	VERY DARK
Crock	Cool Neutral + Blue/Grey Mist	Ice Blue	Light Buttermilk	Graphite	Soft Black
Warm Leaves	Hauser Medium Green	Hauser Light Green		Hauser Dark Green	Black Green
Cool Leaves	Arbor Green	Green Mist	Mint Julep Green	Deep Teal	Black Green
Tulip	Buttermilk	Light Buttermilk	Titanium White	Yellow Ochre + Asphaltum	Soft Black

Transferring the Pattern

[1] Prepare and basecoat the surface as directed on pages 12-14. Then trace the pattern as shown on pages 14-15.

Establish the horizontal base of the pattern 3/4-inch (2 cm) from the bottom of the surface. Draw it in with the pencil. When you're done, hold up the surface and check it visually.

[2] Place easy-release tape below the line. Run your finger along the tape edge to ensure a tight application. Place masking tape on top of the clear tape so that you will be able to determine the shelf line through the tracing paper.

Transferring the Pattern, continued

[3] Place the traced pattern on the prepared surface and visually align it on the shelf. Tape the pattern on the top and bottom left-hand side. Double-check your lines and visually check the pattern to be sure you're ready to transfer the line drawing.

[4] Slip gray transfer paper under the tracing paper. Using the finest end of the stylus, carefully trace the pattern. Use the ruler to trace any straight lines. Keep the transfer lines very light. If your paper is fairly new, apply light pressure on the stylus. At this point, do not transfer details and markings. Double-check the transfer and remove the pattern.

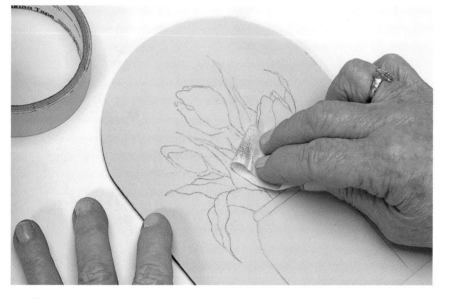

[5] Remove the masking tape from the base line. If your transfer lines appear too dark, roll up some masking tape and press it onto the transferred lines to remove some of the graphite.

HINT

IF YOU'RE RIGHT-HANDED, BEGIN TRACING THE PATTERN ON THE FAR LEFT SIDE AND WORK TOWARD THE RIGHT. FOR LEFTIES, BEGIN ON THE RIGHT AND MOVE LEFT.

Basecoating

[6] Place easy-release tape along each of the horizontal and vertical lines of the crock to insure straight edges. Mix Cool Neutral + Blue/Grey Mist (4:1). Using a no. 12 flat, load both sides of the brush with this mix. Starting slightly in from the edge of the crock, pat the paint on the surface and gradually work out to the edge. This will avoid ridges of paint on the edges of the crock.

Cool Neutral
+ Blue/Grey Mist (4:1)

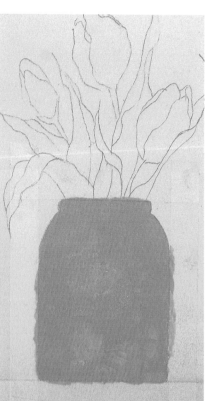

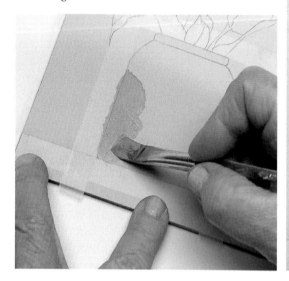

[7] As you continue, keep the brush dampened with water. This first coat should be thin with no buildup of paint. Dry thoroughly. Then run your fingers over the painting to see if you feel any ridges. Lightly sand any ridges and wipe with a tack cloth.

[8] Apply a second coat using longer stokes.

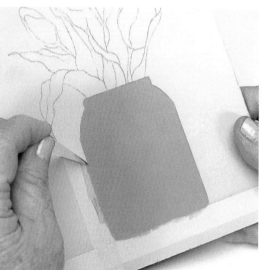

[9] Let the surface dry thoroughly, then carefully remove the tape.

HINT

WHEN RINSING A
BRUSH, PULL THE
BRUSH TOWARD
YOU IN THE TUB.
GOING BACK AND
FORTH MAY PER-
MANENTLY BEND
THE BRISTLES.

Basecoating, *continued*

[10] When the basecoat has been completed, transfer the detail onto the crock. Transfer only the outer edges of the strokes.

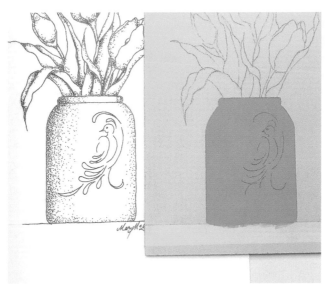

[11] For strokework, use a liner brush that you feel comfortable with. I prefer a short 10/0, but you may use a longer one. Load the liner brush with Arbor Green, thinned with water to the consistency of pure maple syrup. Test the consistency on your palette before applying it to the surface. The paint should flow easily from the tip of the brush. To begin the comma stroke, press the tip of the brush onto the surface to make the thickest part of the marking.

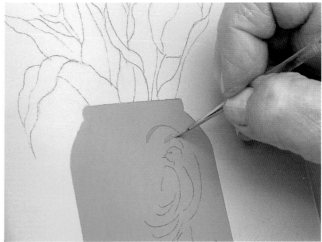

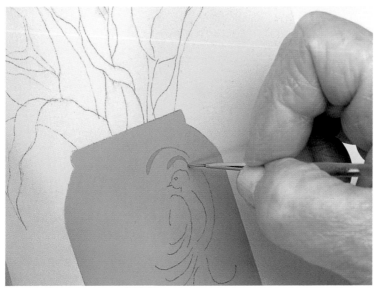

[12] Gradually release pressure while pulling the brush so that the brush tip makes a thin line to form the tail of the stroke.

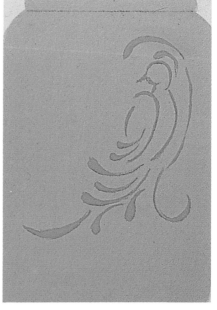

[13] Complete the detail on the crock with strokework.

[14] Using the no. 8 flat, basecoat the tulips with Buttermilk. Again, paint two coats for opaque coverage. Follow the shape of the tulips as you apply the second coat. Basecoat the warm leaves and stems with Hauser Medium Green. Basecoat the cool parts of the leaves with Arbor Green.

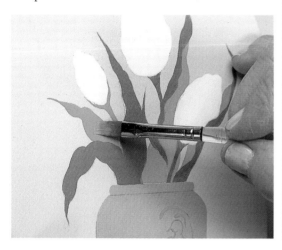

[15] Using the no. 12 flat, basecoat the shelf with Blue/Grey Mist. When the surface is dry, transfer the detail of the tulips and the leaves onto the surface with gray transfer paper.

At this point, spray the surface with two light coats of Krylon Matte Finish 1311. To do this, go outside or to a well-ventilated area. If going outside, remember to respect the environment around you. Place the surface on a piece of cardboard to avoid spraying on the grass or pavement.

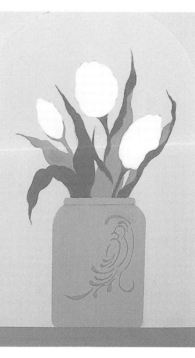

Shading

[16] Create dimensional form by first shading each element in the design. Place a small amount of Permasol Black on the gray palette. Tape the edges of the crock again with easy-release tape. Load the no. 6 flat with Permasol Black, pulling the paint from the puddle and loading both sides of the brush.

Apply a sparse amount of Permasol Black on the dark edges of the crock. Hold the brush near the metal ferrule to maintain control.

[17] With pressure on the same brush, move the paint toward the center of the crock. Gradually melt the color into the basecoat value. Blend in a circular motion and use a good amount of pressure. This project presents a right-hand light source, so the left side of the crock will have the widest dark area with the strongest value change.

Shading, continued

Oops

If some of your shading gets on the background, dip a cotton swab in odorless solvent and rub it off.

[18] With the no. 1 mop, soften the shading one more time. Work in a circular motion with little pressure to refine the value change.

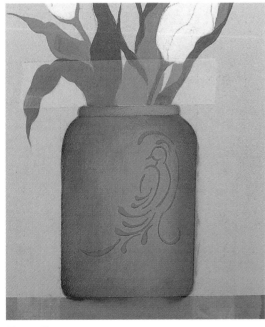

[19] This value change has created dimensional form.

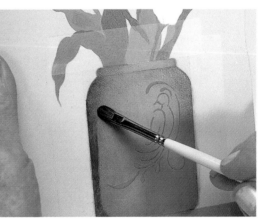

[20] To indicate value change within the dark area, darken the shading on the left side of the crock by applying a second, smaller application of Permasol Black. Then soften this area with a mop brush to create a gradation of value. Remove the tape.

HINT

REFER TO THE PATTERN ON PAGE 24 FOR AN ILLUSTRATION OF THE SHADED AREAS. AREAS THAT HAVE THE MOST DOTS WILL HAVE THE DARKEST SHADING.

[21] Shade the tulips using the same process. Use the no. 0 flat and apply a narrow application of Permasol Black. Soften with the no. 0 mop brush. Then apply a second shading with a brush mix of Raw Sienna + Permasol Black. Place this over the first application and soften. Vary the amount of Raw Sienna, using more when you want a yellowish tinge to the flower.

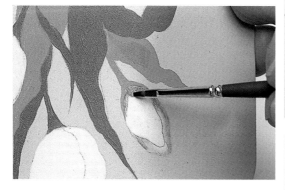

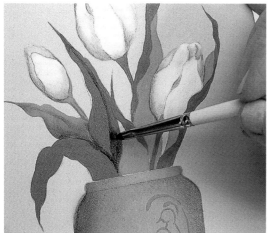

[22] Complete these steps on all the tulips to establish their form.

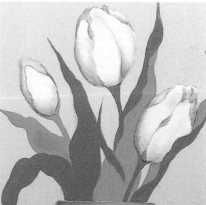

Raw Sienna + Permasol Black

Permasol Black + Terre Verte

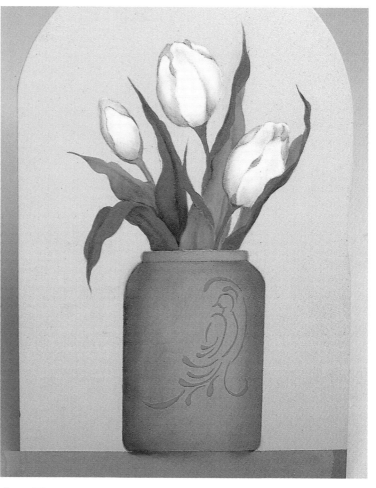

[23] Shade the leaves using a brush mix of Permasol Black + Terre Verte. Vary the brush mix so that each leaf appears a little different. There are many ways to be right. Soften the application with the no. 0 mop to establish a soft gradation of value.

[24] Continue to shade the leaves, moving from left to right across the surface. Refer to pattern to define the areas between leaves.

31

Graining the Shelf and Highlighting

Titanium White + Raw
Sienna

Titanium White +
Cadmium Yellow Light +
French Ultramarine

[25] With Permasol Black on the chisel edge of the no. 6 flat, grain the shelf by moving back and forth according to the perception of the grain. Let some of the basecoat show through the grained application.

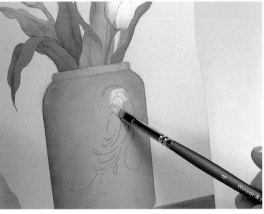

[26] Highlight the crock first to help establish the light source. With a brush mix of Titanium White + a touch of Raw Sienna, establish the highlight at the impact spot on the crock (remember, the light source is from the upper right), using the no. 4 flat. Moving back on the brush handle, blend the impact highlight. Light will follow the shape of the recipient—in this case it follows the contours of the crock.

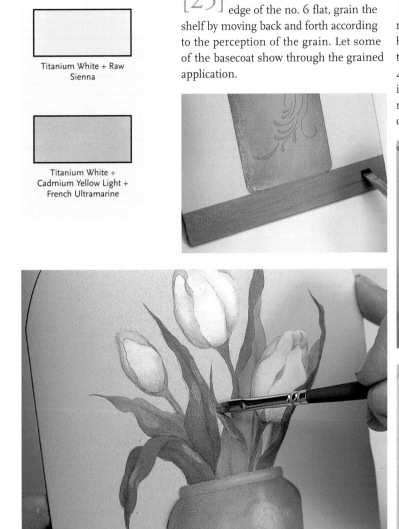

[27] Place and soften the impact highlights on the tulips with the same mix as was used on the crock. Place the impact highlights on the leaves with a light mix of Titanium White + a speck of Cadmium Yellow Light + French Ultramarine. Then soften with a mop brush. Lighten the highlights with a lighter value of the same mix.

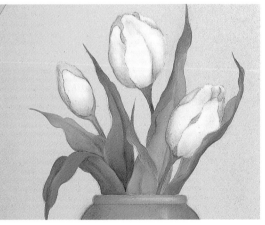

[28] Strengthen the highlights on the tulips.

Final Touches

[29] Paint in the veins of the leaves with the light green using the 10/0 liner. Thin the mix to the consistency of pure maple syrup. Beginning at the growth point (the part of the flower that originates at the stem), pull the vein in the dark center valley of each leaf. Follow the form of the leaf as you paint. I find it easier to pull the vein toward me. Dry thoroughly.

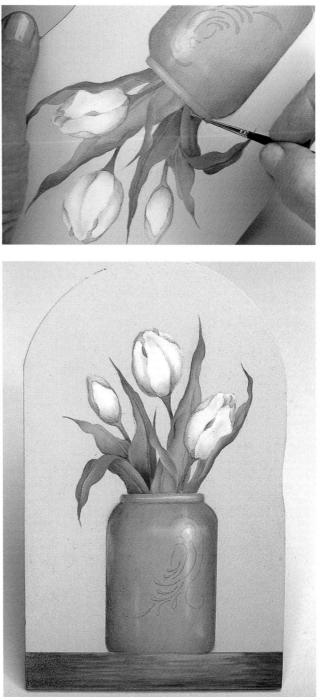

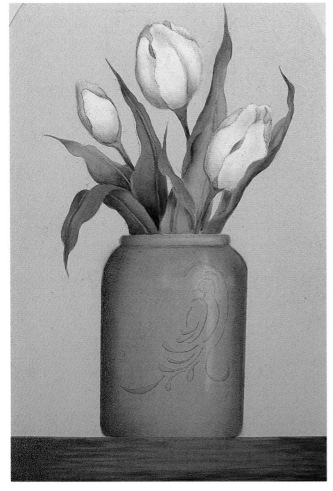

[30] Strengthen the darkest shading areas on all the elements using the previous mixes. Use the application brush position (grasp near the ferrule) to apply the paint with pressure. The blending position (grasping near the end of the brush) will allow you to soften the application with less pressure. If needed, add a speck of Ivory Black to the Permasol Black to strengthen the darkest triangular areas.

[31] Reinforce and soften the impact shines on all the elements. Use the same methods and colors that were used previously. The secondary shines (bounce-back shines and reflected light) that occur on the crock must be lighter in value and follow the form of the crock.

Cabinet

[32] Basecoat the cabinet with Neutral Grey.

[33] Apply an ample amount of Weathered Wood crackle medium to the basecoated cabinet. Let the surface dry for at least an hour.

[34] Using a large brush, apply an overcoat of Buttermilk. Load the brush on both sides with an ample amount of paint. Cover as large of an area as possible with one stroke of the brush. Pull in the direction that you would like the cracks to appear. Crackling will begin immediately. Do not overstroke any area as you will hinder the crackling process.

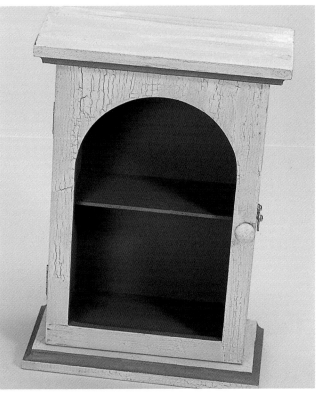

[35] Paint the inside of the cabinet and the trim with Arbor Green. Allow a sufficient curing time for the acrylic paint. If you would like to antique the surface, rub just a touch of Raw Sienna oil paint on the desired areas. Varnish as described on page 15.

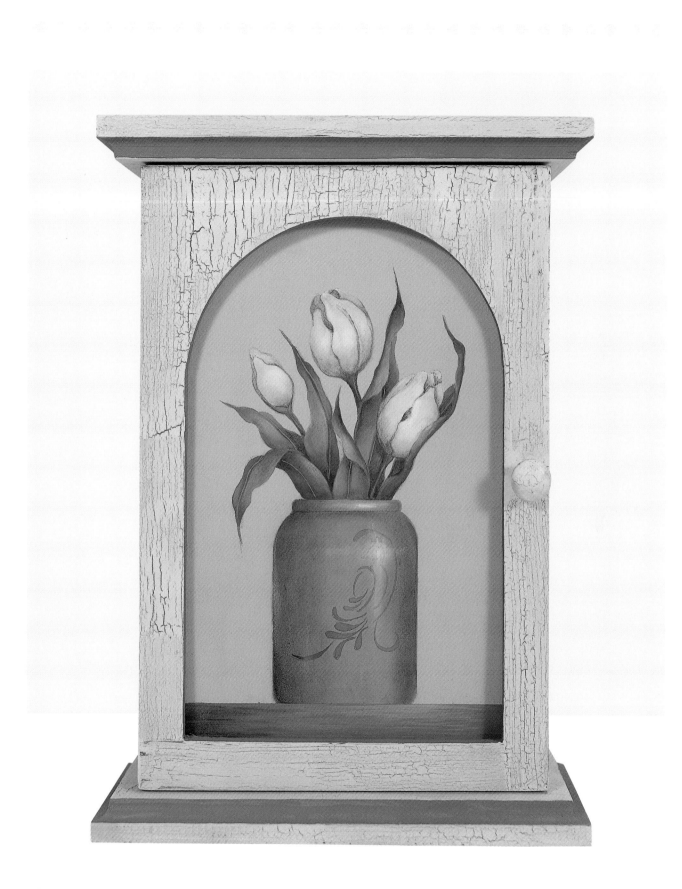

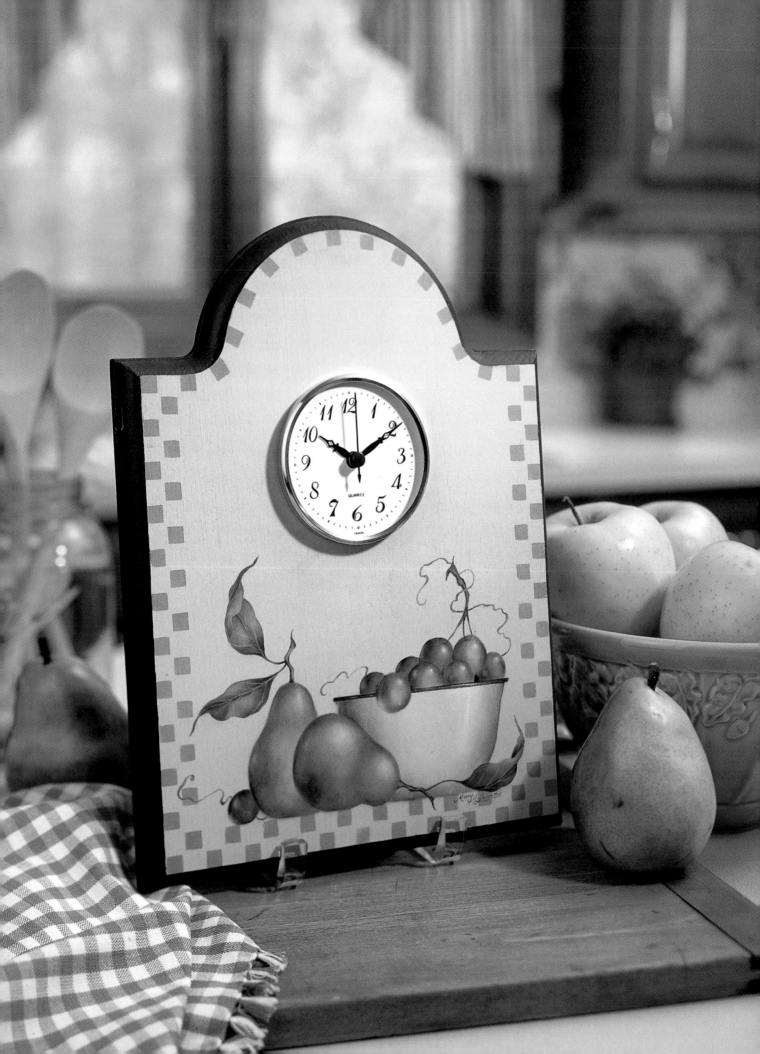

PROJECT TWO

A Time to Enjoy

The sphere is a round, circular shape. In this project,
the spherical form appears in the grapes, in the bottom of the pear,
and as a partial form in the shape of the bowl.
While the cylinder accepts light in a straight line, a sphere is defined
with curved applications of value. Keep in mind that the effect of light is key
to developing a realistic form. Choose one light source and remain
consistent with its implementation.

Paints

DecoArt Americana Acrylic Paints

Soft Blue	Light French Blue	Buttermilk	Grey Sky	Country Red
Green Mist	Hauser Light Green	Hauser Medium Green	Olde Golde	Burnt Umber
Deep Burgundy	Black Plum			

OIL PAINTS

Winton

Titanium White, Raw Sienna,
Terre Verte, French Ultramarine,
Cadmium Red Medium, Permanent
Alizarin Crimson, Cadmium Yellow
Light

Shiva Permasol

Permasol Black, Golden Ochre

Pattern and Materials

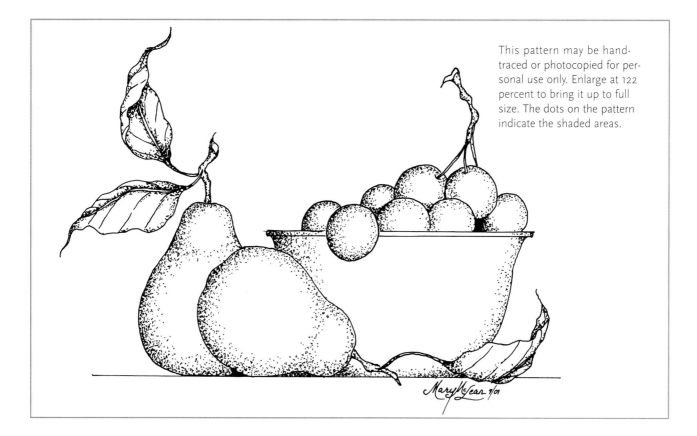

This pattern may be hand-traced or photocopied for personal use only. Enlarge at 122 percent to bring it up to full size. The dots on the pattern indicate the shaded areas.

Materials

BRUSHES

- Royal Brush Aqualon Series 2150 nos. 4, 8 and 10 shaders
- Royal Brush Aqualon Series 2585 no. 10/0 liner
- Royal Brush Series 1112 stencil brush
- Winsor & Newton Series 510 nos. 0, 2, 4, 6 and 8 flats
- Winsor & Newton Series 540 no. 10/0 liner
- Ann Kingslan mops nos. 0 and 1

ADDITIONAL SUPPLIES

Sanding discs, tack cloth, wood sealer, sponge roller, pencil, gray transfer paper, stylus, gray palette, Archival Odorless Solvent, paper towel, easy-release tape, Krylon Matte spray, 1/2-inch (1.2cm) square stencil

SURFACE

- Clock, item 24-9753, from Viking Woodcrafts, Inc.

Acrylic Conversion Chart

If you choose to paint this project entirely with acrylics, consider the following conversions using DecoArt Americana Acrylics.

OBJECT	BASECOAT	LIGHT	HIGHLIGHT	DARK	VERY DARK
Green Pear	Hauser Light Green	Olive Green	Yellow Light	Hauser Medium Green	Hauser Dark Green
Yellow Pear	Olde Gold	Marigold	Cadmium Yellow	Honey Brown	Burnt Umber
Bowl	Buttermilk + Grey Sky	Light Buttermilk	Titanium White	Graphite	Graphite
Bowl Trim	Country Red	Cherry Red	Cadmium Yellow		
Warm Leaves	Hauser Medium Green	Hauser Light Green		Hauser Dark Green	Black Green
Cool Leaves	Green Mist	Mint Julep Green		Deep Teal	Black Green
Gray Grapes	Grey Sky	Titanium White		Graphite	
Green Grapes	Hauser Light Green	Olive Green	Yellow Light	Hauser Medium Green	
Stems	Burnt Umber	Honey Brown	Buttermilk		
Grape Glazes	Alizarin Crimson	Cherry Red	Cadmium Yellow then Titanium White		

Surface Preparation

[1] Sand the surface. Use a tack cloth to clean off the excess particles. Apply wood sealer and let the surface dry. Sand lightly and wipe off excess dust. Using a sponge roller, apply one coat of Soft Blue. Lightly sand and wipe off excess dust. Apply a second coat of paint.

[2] Paint a checkerboard pattern around the surface using a 1/2-inch (1.2cm) checkerboard stencil. Load the stencil brush with Light French Blue, then unload it on the paper towel. Position the stencil along the outside edge of the surface. Using a sparse amount of paint, move in a circular motion to fill in the squares. Pull the paint from the outside of each square into the center to avoid paint ridges at the outside edge.

Basecoating and Shading

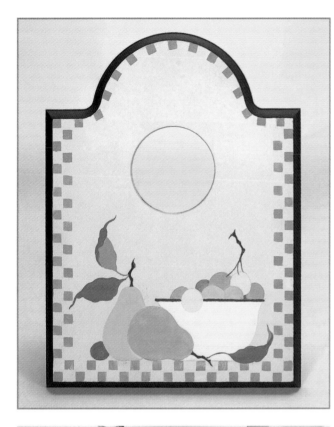

[3] Stencil a single row of squares along the rounded top with Light French Blue. Position the stencil and paint one square at a time. Reposition the stencil and paint another one.

When the paint has dried, transfer the pattern to the surface. Basecoat each design element with acrylics, referring to the chart on page 39 for color placement. Paint the inner trim with Deep Burgundy and the outer rim with Black Plum.

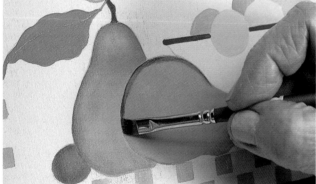

[4] Working from left to right, begin shading the pears. Follow the curved spherical form of the pear as you paint these dark areas. Lay in the shading on the green pear with Permasol Black with the no. 6 flat brush. Then work out the shading and soften with the mop. For the yellow pear, begin with a brush mix of Raw Sienna + Permasol Black and work out with the brush. Soften this area with the no. 1 mop to form a gradation of value on the form.

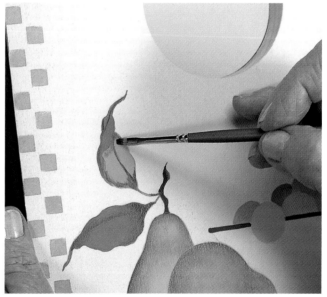

[5] Shade the leaves with a brush mix of Permasol Black + Terre Verte. Use the no. 2 brush to lay in the color, then work out the color and soften with a mop.

[6] Tape off the top and bottom edges of the bowl with easy-release tape. Shade the bowl using the no. 6 flat and a brush mix of Permasol Black + Raw Sienna. Paint the widest area of dark on the left side of the bowl.

[7] Soften the shading with a no. 1 mop.

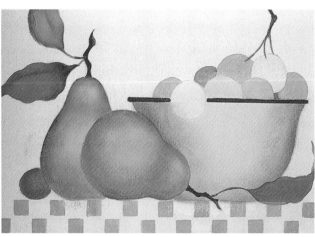

[8] To shade the grapes, lay in a bit of color as you establish the form. For the darker grapes, use Permasol Black + Permanent Alizarin Crimson; for medium value grapes, use Permanent Alizarin Crimson only. For the lightest grapes, use Cadmium Red Medium + just a touch of Permanent Alizarin Crimson. No two grapes are the same, so use the colors any way that you choose.

[9] Soften the shading using the no. 0 mop brush.

HINT

REFER TO THE PATTERN ON
PAGE 38 FOR AN ILLUSTRATION
OF THE SHADED AREAS.

Permasol Black + Raw Sienna

Permasol Black + Terre Verte

Permasol Black + Permanent Alizarin Crimson

Cadmium Red Medium + Permanent Alizarin Crimson

Shading, *continued*

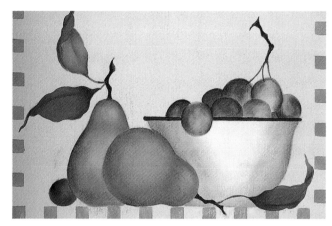

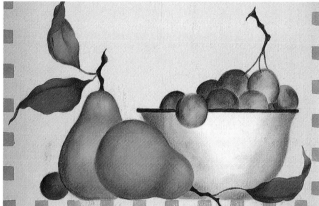

[10] Complete the shading and softening on the rest of the grapes and the leaf on the table.

[11] If necessary, enhance some of the very dark areas with Permasol Black + Raw Sienna to create stronger form. Here I darkened the shading on the pears, leaves and bowl.

Highlighting

[12] *(Top Right)* Highlight the leaves using a light green mix of Titanium White + a touch of Cadmium Yellow Light + a touch of French Ultramarine. Lay on the color with the no. 4 flat and soften with the no. 0 mop.

[13] *(Bottom Right)* To highlight the green pear, lighten the previous mix slightly with more Titanium White. For the yellow pear, add a bit of Raw Sienna + Cadmium Yellow Light to the green pear mix. Soften the application with the no. 1 mop to graduate the highlight.

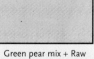

Titanium White + Cadmium Yellow Light + French Ultramarine

Green pear mix + Raw Sienna + Cadmium Yellow Light

[14] The grapes are multiple circular forms that all accept light from the same light source. Be careful not to move your light source as you paint the grapes. With a no. 0 flat, dampen the highlight area of the grapes with a bit of Golden Ochre. This helps prepare the highlight area for the first application of highlight. With a mix of Titanium White + Raw Sienna, highlight the grapes with the no. 0 flat brush. Place the highlight in the upper right-hand quadrant of each sphere. Build the highlights progressively in smaller applications.

[15] Highlight the bowl with the Titanium White + Raw Sienna mix and complete any remaining leaves or grapes to this point. Soften with an appropriate-sized mop.

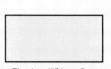

Titanium White + Raw Sienna

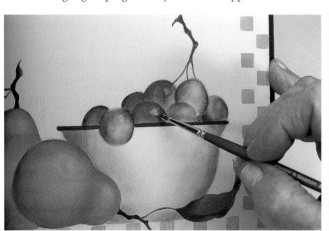

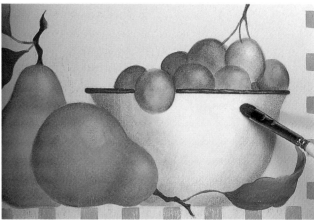

Final Touches

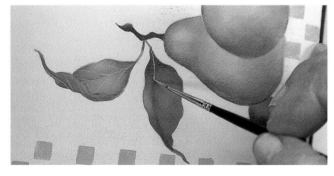

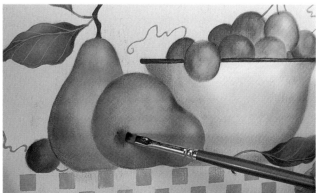

[16] Add veins to the leaves with the no. 10/0 liner brush using a thinned application of the light green mix. The vein color should be slightly lighter than the area on which it is placed, so test the value before applying. Dry thoroughly. If you wish to proceed immediately, you may spray dry the surface with Krylon 1311. If not, I would set the surface under a painting light, and it will dry in several hours.

[17] Now, begin to tie together the elements of the composition by adding some grape color as accents on the pears. Use Permanent Alizarin Crimson on the green pear and Cadmium Red Medium with a touch of Permanent Alizarin Crimson for the yellow pear. Apply the color with the no. 6 flat.

Final Touches, continued

[18] Soften the accents with the no. 1 mop. Apply a tiny amount of Permanent Alizarin Crimson onto the leaves. Soften the application with the no. 0 mop. Apply Raw Sienna as an accent color on the bowl. If necessary, brighten some of the color on the grapes as well.

[19] Add final highlights to the grapes with Titanium White. Soften this highlight with the mop. Apply a secondary shine at the seven o'clock area on each sphere. Use the excess paint on the mop bristles to place the shine on the grapes. This light area must be submissive to the part of the grape that has the primary impact shine. Add a "ping" of final shine to this primary impact area with Titanium White. Do not soften this with the mop.

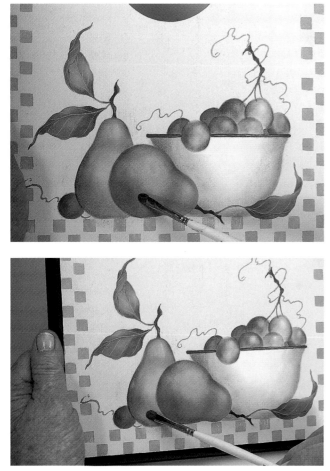

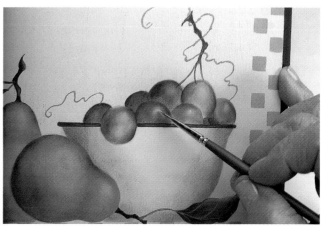

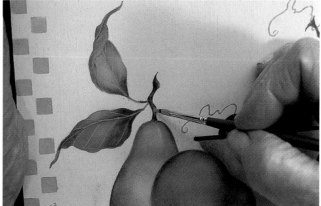

[20] Moisten the highlight area of the green pear with the light green vein mix. Build a stronger shine. Add a cool reflected light to the pear with a mix of Titanium White + a touch of French Ultramarine. Use a sparse amount of paint. Remember that reflected light follows the shape of the object that receives the light.

[21] Lighten the stems slightly with a mix of Titanium White + Raw Sienna on the no. 0 flat. Soften if needed with the no. 0 mop.

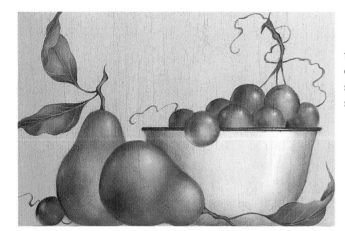

[22] Evaluate the lights and darks in the painting. Adjust if necessary with repeat applications. Allow the painting to dry completely. Remove dust from the painting with a tack cloth. In a well-ventilated area, apply one coat of Krylon Satin spray. Let the surface dry. Apply two additional coats using the same procedure.

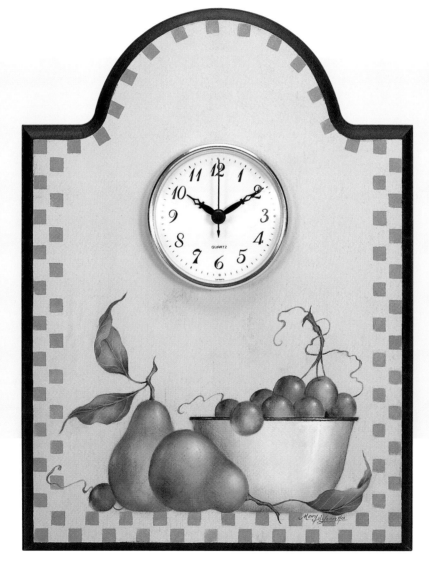

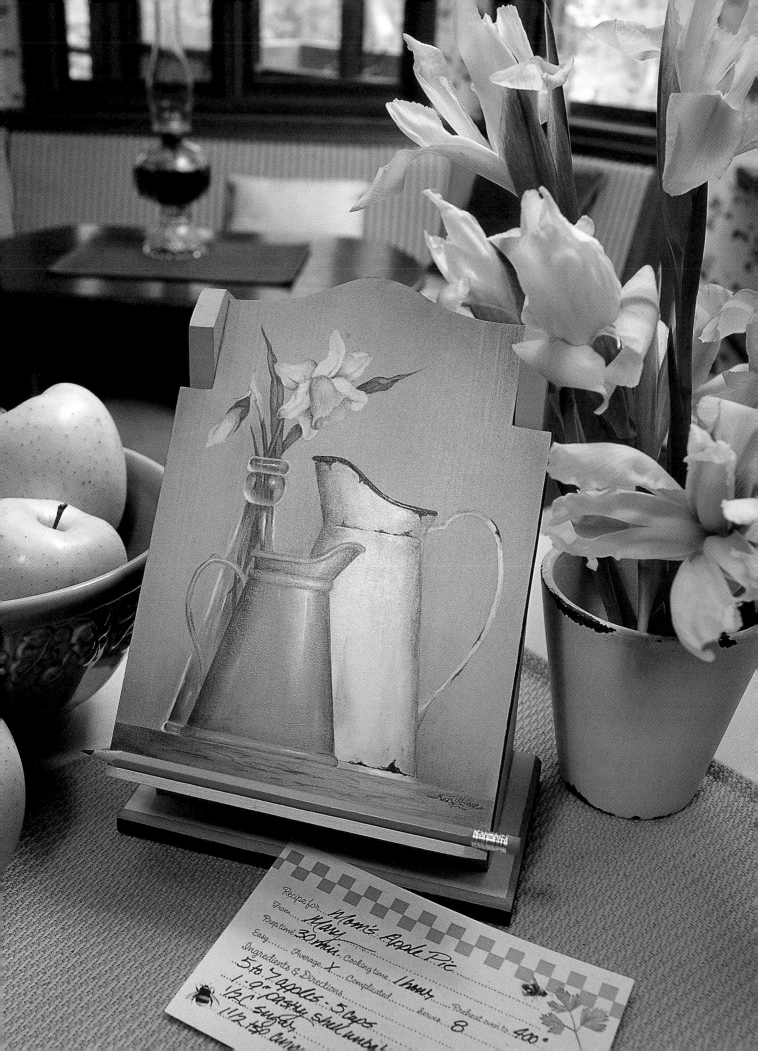

PROJECT THREE

Breath of Spring

A cone is a solid form that evenly slopes to a point
from a circular base, but cones are rarely defined by their entire form. Most often they stop short of the point and merge into an adjoining form. In this project, the vase, the pitchers and even the daffodil are variations on the cone shape.

Paints

DecoArt Americana Acrylic Paints

Sand	Salem Blue	Antique Teal	Lamp Black	Taffy Cream
Moon Yellow	Camel	Yellow Ochre	Hauser Medium Green	Charcoal Grey
Burnt Umber	Khaki Tan	Raw Sienna		

OIL PAINTS

Winton

Titanium White, Cadmium Yellow Light, Raw Sienna, Terre Verte, Ivory Black

Shiva Permasol

Permasol Black

Pattern and Materials

Materials

BRUSHES

- Royal Brush Aqualon
 Series 2150 nos. 4, 8
 and 10 shaders

- Royal Brush Aqualon
 Series 2585 no. 10/0 liner

- Winsor & Newton Series 510
 nos. 0, 2, 4, 6 and 8 flats

- Winsor & Newton
 Series 540 no. 10/0 liner

- Ann Kingslan mops
 nos. 0, 1, 2, and 4

ADDITIONAL SUPPLIES

Sanding disc, tack cloth, wood
sealer, sponge brush, sponge
roller, water basin, pencil, trac-
ing paper, gray transfer paper,
stylus, gray palette, Archival
Odourless Solvent, easy-release
tape, Krylon Matte Finish 1311

SURFACE

- Slant lid recipe box from
 Wayne's Woodenware

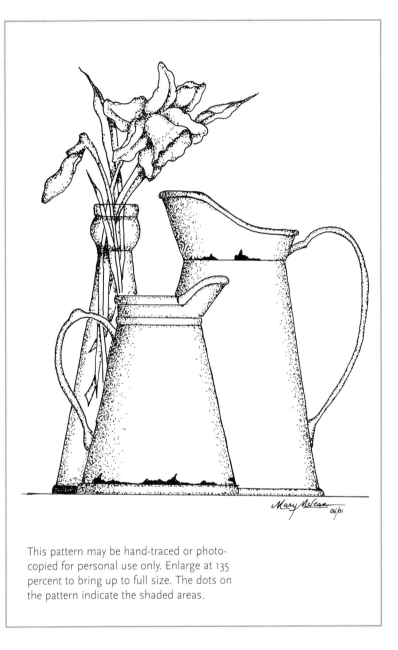

This pattern may be hand-traced or photo-
copied for personal use only. Enlarge at 135
percent to bring up to full size. The dots on
the pattern indicate the shaded areas.

Acrylic Conversion Chart

If you choose to paint this project entirely with acrylics, consider the following conversions using DecoArt Americana Acrylics.

OBJECT	BASECOAT	LIGHT	HIGHLIGHT	DARK	VERY DARK
Off-white Pitcher	Sand	Light Buttermilk	Titanium White	Yellow Ochre	Honey Brown
Pitcher Rim	Lamp Black	Light Buttermilk			
Pitcher Rust	Raw Sienna, Burnt Umber				
Blue Pitcher	Salem Blue	Sea Aqua	Light Buttermilk	Dessert Turquoise	Blue Green
Glass Vase	Wash of Charcoal Grey	Light Buttermilk	Titanium White		Charcoal Grey
Leaves	Hauser Medium Green	Hauser Light Green		Hauser Dark Green	Black Green
Lightest Daffodil Petals	Taffy Cream	Light Buttermilk		Golden Straw	
Darker Daffodil Petals	Moon Yellow	Taffy Cream		Honey Brown	
Shelf	Camel	French Vanilla		Honey Brown	

Basecoating

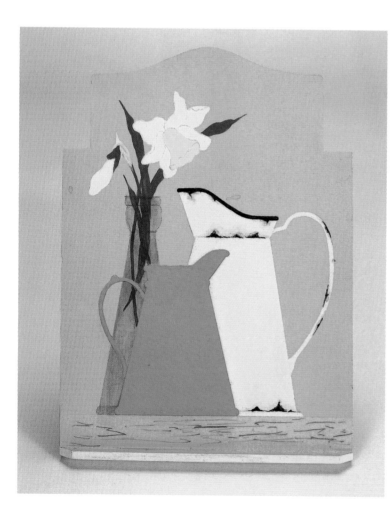

[1] Sand the surface. Use a tack cloth to clean off the excess particles. Apply wood sealer and let the surface dry. Sand lightly and wipe off excess dust. Using a sponge roller, apply one coat of Khaki Tan to the cover of the box. Paint the bottom of the box with Yellow Ochre and the trim with Antique Teal. Lightly sand and wipe off excess dust. Apply a second coat of paint. Transfer the pattern.

Basecoat all the elements in the design, referring to the chart above for color placement. Do not basecoat the flowers opaquely—allow some of the background to show through to keep the flower from looking too stiff.

Shading

[2] Create the form of the flowers by shading with Raw Sienna + a touch of Permasol Black. Apply the paint and diffuse with the side of the no. 0 flat, then soften with the no. 0 mop. Hint: Do not overload your brush with paint. Applications of paint should be very sparse. The oil paint will go a long way.

[3] Define the form of the leaves with a mix of Permasol Black + Terre Verte using the no. 0 flat brush. For the stems in the vase, just shade to separate the stems—glass will diffuse its contents so stems need not be in clear focus. Create the strongest detail on the items outside the glass vase.

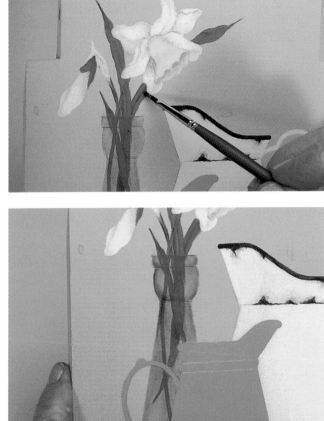

Raw Sienna + Permasol Black

Permasol Black + Terre Verte

HINT

REFER TO THE PATTERN ON PAGE 48 FOR AN ILLUSTRATION OF THE SHADED AREAS.

[4] Create the form of the bottle through the definition of dark values. Glass is a transparent form, and its surface will cast a shadow inside the container. Using a no. 4 flat brush, apply a small amount of Permasol Black to the inner edge of the bottle.

[5] Using a no. 2 mop, soften the application to create a graduated change.

[6] The two pitchers can be related to the cone shape. These forms are broken up into an upper and lower area. Using Permasol Black, lay in shading on the upper portion of the blue container and softly mop to create the conical form. Lay the same paint under the top edge of the container to form the rolled edge.

[7] Tape off the straight sides of the container, then with a no. 6 flat, lay Permasol Black on each side of the container. Keep in mind that the widest dark area exists at the point that is the furthest from the light source. Here the light is from the right, so the left side has the widest dark area.

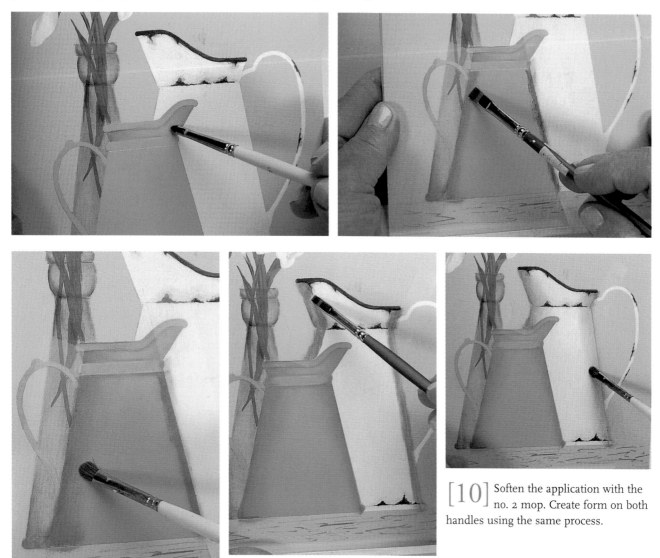

[8] Using a no. 2 mop, soften the application to create a graduated change.

[9] Using Permasol Black, lay in the shading on the off-white container and softly mop to create the conical form. The effect of the dark area will follow the shape of the container.

[10] Soften the application with the no. 2 mop. Create form on both handles using the same process.

Background and Accents

[11] *(Left)* Using Raw Sienna on the no. 8 flat brush, create a variegated background. Place the paint behind the containers and at the upper edges. This addition creates atmosphere and color repetition.

[12] *(Right)* Work out the color with the same flat, then soften it with the no. 2 mop.

[13] Shiny surfaces will accept a color reflection from a nearby object. Using a brush mix of Terre Verte + a speck of Permasol Black on a no. 4 flat, apply the reflected light from the blue metal container onto the off-white container and the glass vase. The reflection must follow the shape of the recipient. Soften with the no. 2 mop.

[14] Color accents provide variety and interest within a large area. Apply accents of Raw Sienna oil paint to several areas on both containers. Vary the size and placement of these warm color accents. Soften with the no. 2 mop.

Additional Shading and Highlighting

[15] With Permasol Black + Raw Sienna, darken the left corner of the shelf with the no. 8 flat. Work the color back and forth as you move to the right.

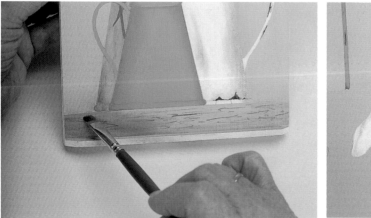

[16] Adjust some of the darks in the daffodils and leaves, especially on parts that appear above the glass. Use the same colors as used in steps 2 and 3.

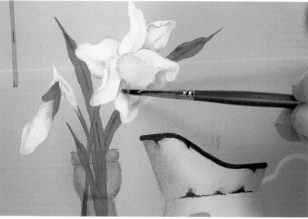

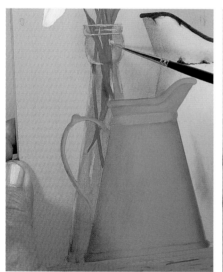

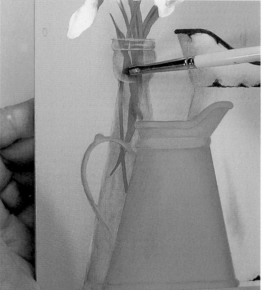

Titanium White + Raw Sienna + Permasol Black

Titanium White + Raw Sienna

[17] Glass can have a very eye-catching effect, but in this composition, we want the glass to remain in the background. To do this, create shines that aren't very strong with a no. 4 flat. Begin the effect of light on this container by indicating the impact shine on the rounded part of the bottle. With Titanium White + a speck of Raw Sienna + a speck of Permasol Black, apply paint to the impact areas.

[18] Soften these impact shines with the no. 0 mop. Add a final, or impasto, shine with Titanium White + Raw Sienna, but do not soften this shine.

HINT

WHEN PAINTING GLASS, THERE CAN BE LOST AND FOUND EDGES, MEANING THAT NOT ALL THE EDGES WILL BE CLEARLY DEFINED. LIGHT WILL VERY SELDOM FOLLOW A STRAIGHT EDGE, BUT WILL HIT AND MISS ON SUCH A REFLECTIVE SURFACE.

Highlighting, continued

[19] Establish the highlights on the blue pitcher using the same mix as was used for the impact shines on the glass.

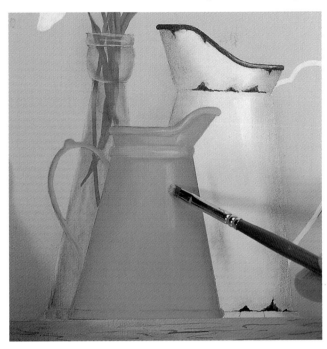

[20] Soften the highlights on the pitcher with the no. 2 mop. Then add highlights to the white pitcher with the same mix and diffuse the application. Using the appropriate sized brush, highlight the leaves with the same color as well. Dry thoroughly.

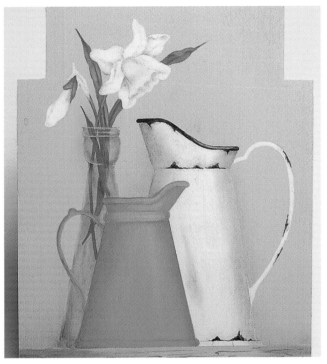

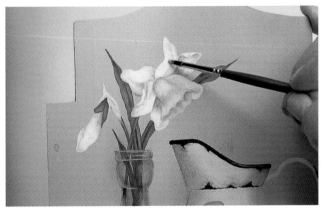

Titanium White + Cadmium Yellow Light

[21] Using a sparse amount of Cadmium Yellow Light on the no. 2 flat, dampen the highlight area of the trumpet part of the flower. Apply Titanium White into the dampened area and blend out into the petal with the no. 2 flat.

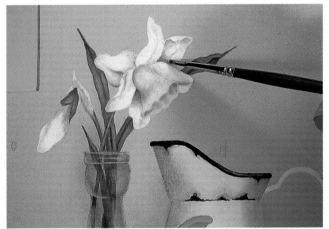

[22] With a mix of Titanium White + Cadmium Yellow Light on the no. o flat, lay in the highlights on the stems above the glass. Strengthen the darkest shaded areas of the daffodil with the Raw Sienna + Permasol Black mix on the no. o flat. Diffuse and soften the area with the no. o mop.

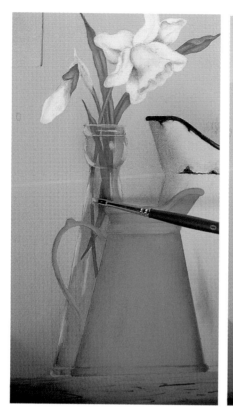

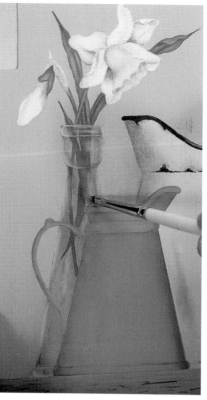

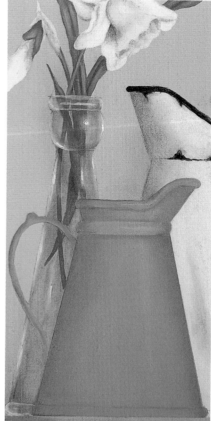

[23] Using the no. 0 flat, strengthen the impact area on the glass with a lighter mix of Titanium White + Raw Sienna + a touch of Permasol Black.

[24] Soften areas with the no. 0 mop.

[25] With the liner brush you use with oil paints, add the brightest highlights to the glass vase. Soften the first application slightly. Then apply an even smaller highlight and do not soften the application.

HINT

THE EFFECT OF REALISM IS DEPICTED WHEN
THERE IS VALUE CHANGE WITHIN BOTH THE
LIGHT AND DARK AREAS. GLASS WILL LOOK
REAL IF THERE ARE DIFFERENT VALUES OF
LIGHT IN THE LIGHT AREA, THE LIGHTEST
OF WHICH IS THE IMPASTO SHINE.
HAVE PATIENCE AND BUILD THE SHINES ON
GLASS VERY SLOWLY WITH MULTIPLE LAYERS
OF APPLICATION AND BLENDING.

Final Touches

[26] Strengthen the darkest darks on the two pitchers using Permasol Black on the no. 6 flat. Soften with a mop.

[27] Metal surfaces do not absorb light and have stronger highlights. Much of the light is reflected off the impact area and can reflect the image of the source. Strengthen the highlights on the pitchers with Titanium White and the 10/0 liner brush. Each application should occur in a smaller area than the previous application. Do not soften the last application.

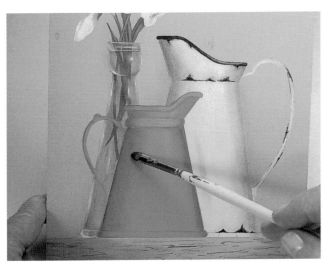

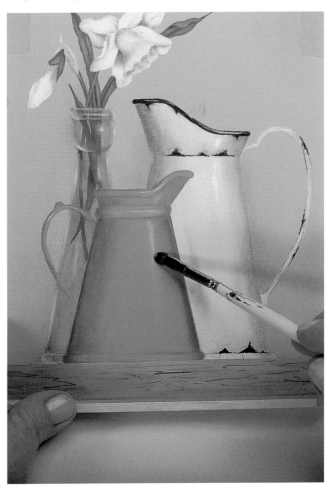

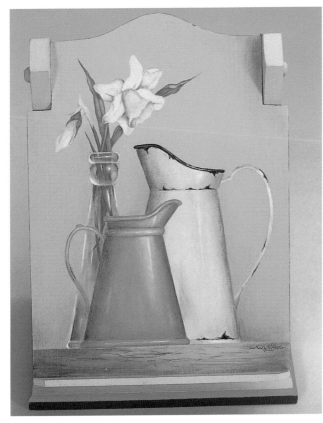

[28] Continue to strengthen the very dark areas, then add the final brightest shines. Varnish as described on page 15.

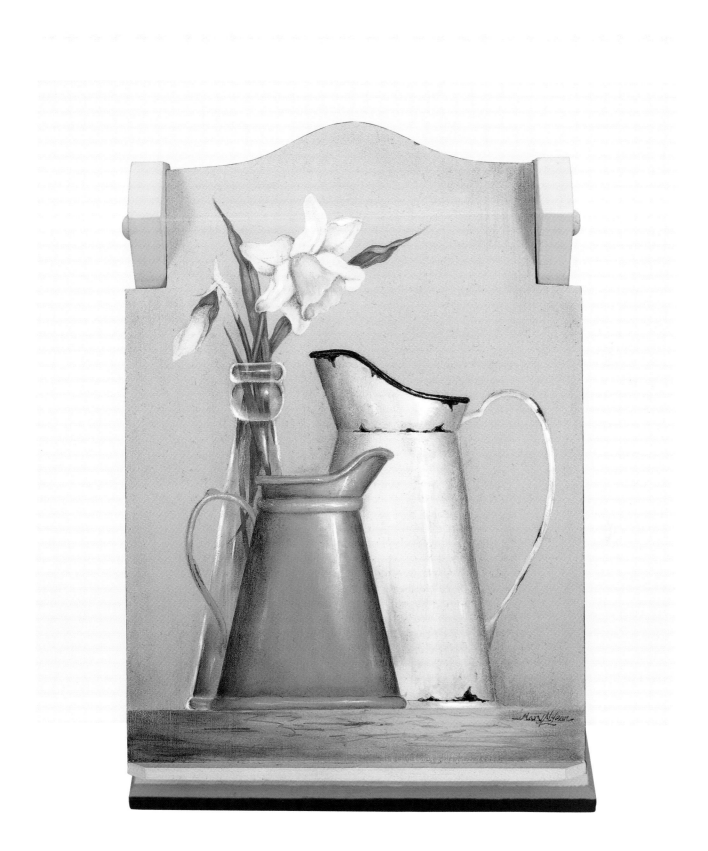

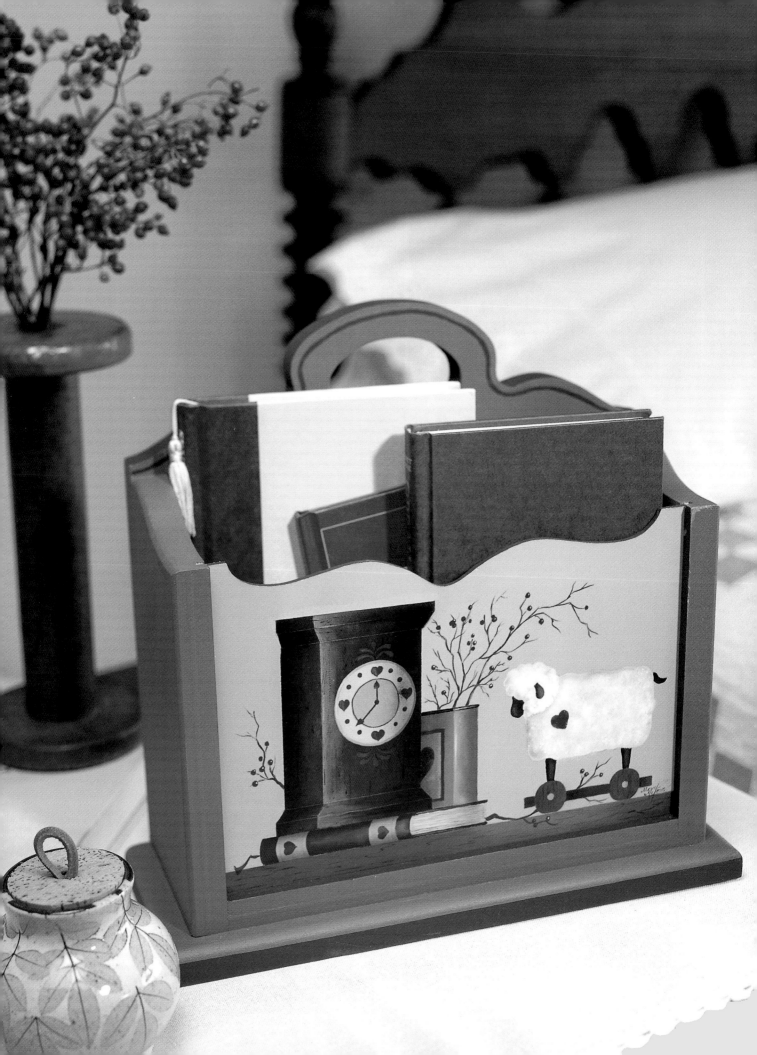

4

Country at Heart

A cube is a solid surface that has six faces; top, bottom, and four sides. Careful attention must be paid to the effect of light on the cubical surface. As the plane of surface changes, so does the application of light. It must follow the shape of the surface it is cast upon. Because of this the cubic shape is most easily observed when it is placed on an angle so the viewer can see more than one side. In this project the containers and the book are sitting at an angle. A more difficult observation may be the placement of a cube at eye-level perspective that shows only one side. Here, the sheep is a cube with only one side on view.

Paints

DecoArt Americana Acrylic Paints

Lamp Black	Deep Midnight Blue	Dove Grey	Light French Blue	Driftwood
Hauser Dark Green	Country Red	Rookwood Red	Heritage Brick	Sand
Milk Chocolate	Burnt Umber	Khaki Tan		
Marigold	Mississippi Mud			

OIL PAINTS

Winton

Titanium White, Raw Sienna, Terre Verte, Cadmium Yellow Light

Shiva Permasol

Permasol Black, Golden Ochre

59

Pattern

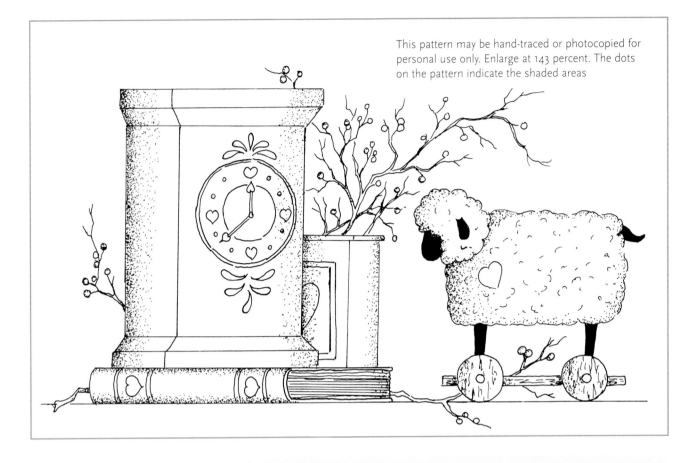

This pattern may be hand-traced or photocopied for personal use only. Enlarge at 143 percent. The dots on the pattern indicate the shaded areas

Materials

BRUSHES

- Royal Brush Aqualon Series 2150 nos. 4, 8 and 10 shaders
- Royal Brush Aqualon Series 2585 no. 10/0 liner
- Winsor & Newton Series 510 nos. 0, 2, 4, 6, 8 and 10 flats
- Winsor & Newton Series 540 no. 10/0 liner
- Ann Kingslan mops nos. 0, 1 and 2
- old scruffy brush

ADDITIONAL SUPPLIES

Sanding disc, tack cloth, wood sealer, sponge brush, sponge roller, water basin, pencil, tracing paper, gray transfer paper, stylus, gray palette, Archival Odourless Solvent, easy-release tape, Krylon Matte Finish 1311

SURFACE

- Magazine box, item 147, from Bush's Smoky Mountain Wood Products

Acrylic Conversion Chart

If you choose to paint this project entirely with acrylics, consider the following conversions using DecoArt Americana Acrylics.

OBJECT	BASECOAT	LIGHT	HIGHLIGHT	DARK	VERY DARK
Clock	Hauser Dark Green	Hauser Light Green			Graphite
Inner Face	Khaki Tan				
Outer Face	Sand				
Trim	Marigold				
Hands	Rookwood Red				
Strokes	Country Red				
Book	Deep Midnight Blue	Uniform Blue		Paynes Gray	Graphite
Pages	Sand	Light Buttermilk		Yellow Ochre	
Label on Book	Khaki Tan				
Heart on Book	Rookwood Red				
Tin	Light French Blue	Dove Grey		French Grey Blue	
Label on Tin	Khaki Tan				
Trim	Country Red				
Heart on Tin	Rookwood Red				
Sheep	Dove Grey	Titanium White		Slate Grey	
Legs, Face, Ears	Lamp Black	Slate Grey			
Heart on Sheep	Country Red				
Wheels	Milk Chocolate	Sable Brown		Bittersweet Chocolate	
Base	Rookwood Red	Cherry Red		Antique Maroon	
Branches	Burnt Umber	Honey Brown			
Berries	Country Red	Cherry Red			
Shelf	Mississippi Mud	Sable Brown		Bittersweet Chocolate	

Basecoating

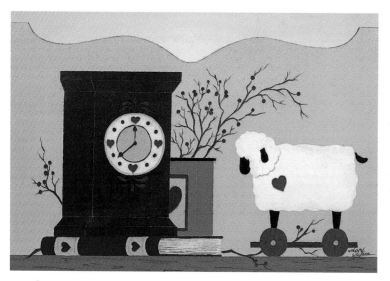

[1] Sand and seal the wood surface. Apply one coat of Mississippi Mud. Sand lightly and apply a second coat. Use Heritage Brick to line the trim.

Lightly sand the masonite. With a sponge roller, apply one coat of Driftwood. Lightly sand again and apply a second coat of paint. Trace and transfer the pattern. Transfer only basic forms. Basecoat areas with acrylic color, referring to the chart above for color placement. Retransfer details as needed and basecoat these elements. When dry, spray with Krylon 1311 in a well ventilated area.

Shading

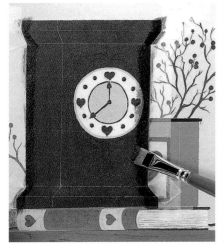 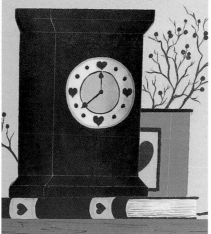 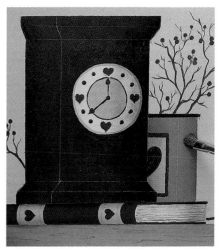

[2] Place easy-release tape on the outer form of the clock to separate it from the background. Using the no. 10 flat, apply Permasol Black along the sides of the clock.

[3] Soften the area with the no. 2 mop. Even though the light source is from the upper right, the right side of the clock contains a wide area of dark because the clock is sitting at an angle. Remove the tape when you have created a graduated blend of paint. Shade on the left side of each berry.

[4] Remove the tape from the sides of the clock. Tape off and apply the shading to the tin and the book (see pattern for shading placement). Soften the shading with a no. 1 mop.

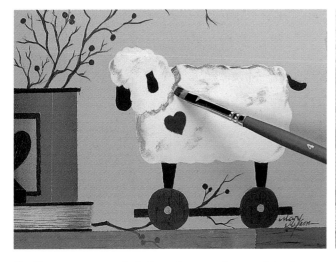 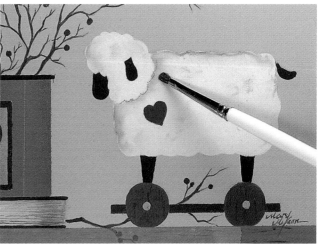

[5] Using Permasol Black on the no. 4 flat, rough in the shading on the sheep. Define tufts of wool and separate the head from the body.

[6] Then soften the applications with the no. 1 mop.

[7] Shade the shelf with Permasol Black on the no. 10 flat. Work with a back and forth motion as you blend from side to side. Concentrate the largest shading area on the left-hand side and place a smaller area on the right. With the no. 4 flat, apply the shading of Permasol Black to the wheel and base of the sheep.

[8] Soften the shading with the no. 1 mop.

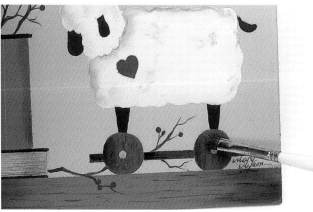

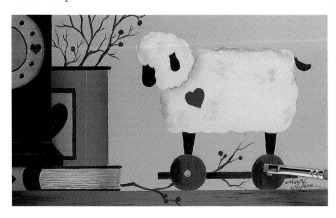

Highlighting

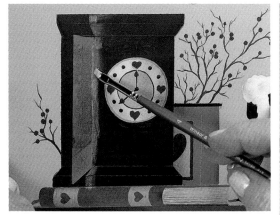

[9] Tape off the front corner and bottom of the clock. This will help to delineate the corner edge of the clock. Brush mix Titanium White + Raw Sienna + a touch of Terre Verte. With the no. 4 flat, apply this highlight color to the advancing (front) edge of the cube. This will be the lightest area on the clock.

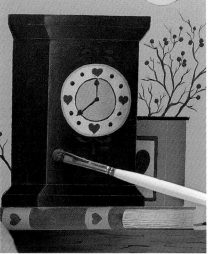

[10] Soften the application with the no. 1 mop. Remove the corner tape and make any final blending adjustments.

Titanium White + Raw Sienna + Terre Verte

Highlighting, continued

Titanium White + Raw Sienna

[11] Place a piece of tape to the left of the turning corner on the blue tin. Apply a highlight mix of Titanium White + Raw Sienna to the right of the tape. Blend it out with the no. 1 mop.

[12] Remove all the tape. With any paint that's left on the mop after blending the blue container, highlight the spine of the book. If needed, add more highlight (Titanium White + Raw Sienna) to the spine and pages of the book with the no. 4 flat and blend out with the no. 0 mop.

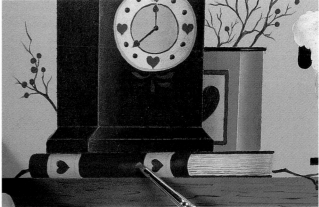

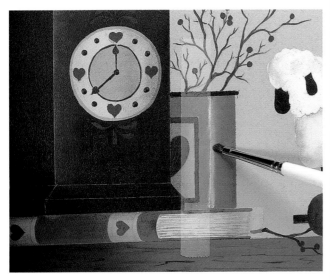

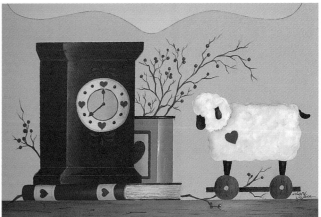

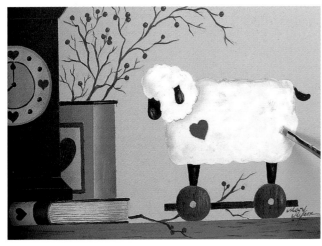

[13] With a lighter mix of Titanium White + Raw Sienna, add tufts of highlights to the body of the sheep using a scruffy brush. With a liner, highlight the berries with a brush mix of Titanium White + Cadmium Yellow Light.

[14] Using some leftover paint that is on the mop, highlight the sheep's ear, muzzle and legs. Warm the highlight of the shelf with Raw Sienna + a touch of Titanium White and soften the application from side to side.

Continue to adjust the lights and darks in relationship to each other. Varnish as directed on page 15.

HINT

WHEN YOU WOULD LIKE TO PLACE LESS
PRESSURE ON THE BRUSH, MOVE YOUR
GRASP FURTHER UP ON THE BRUSH HANDLE.

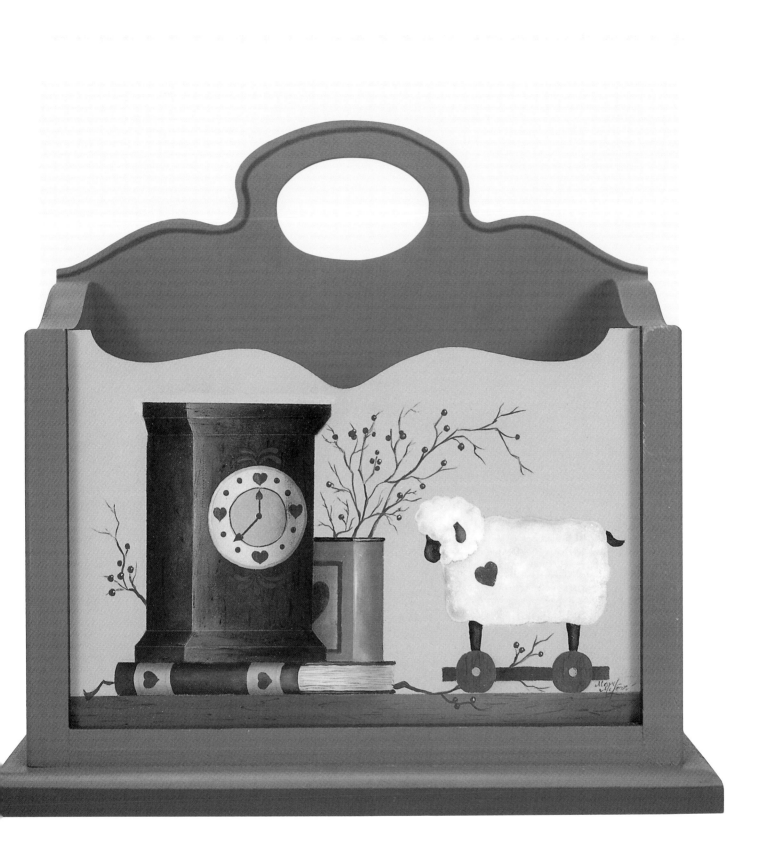

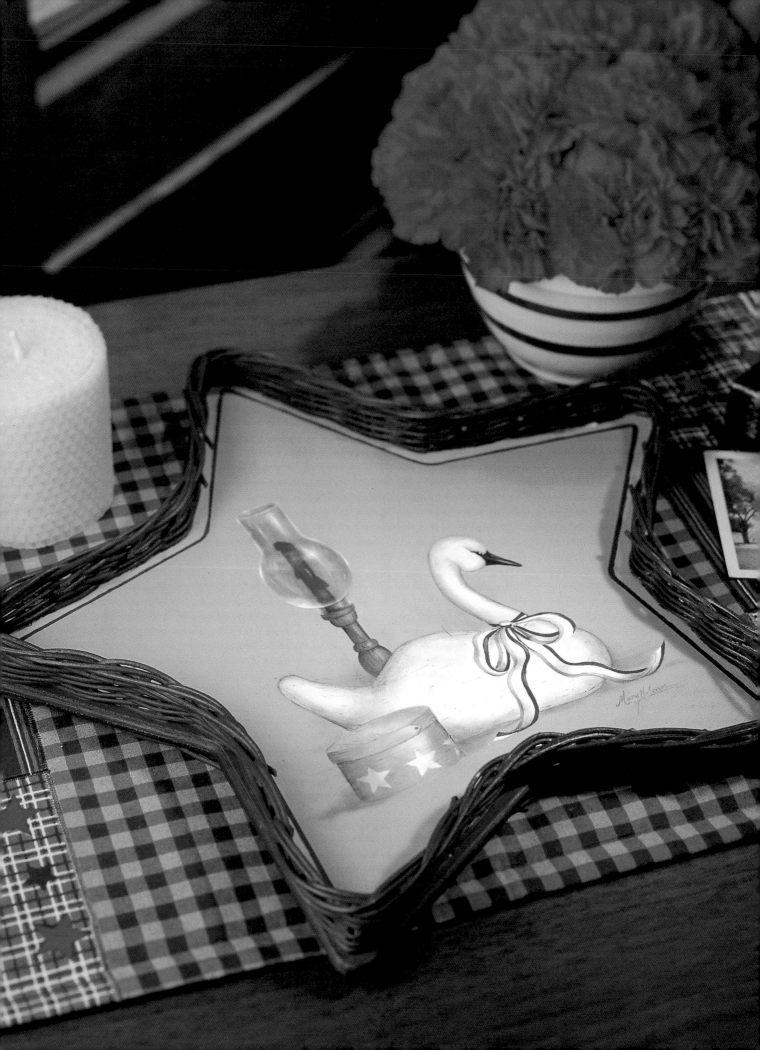

5

Star of the Show

As was discussed in chapter two, page 17, there are three viewing perspectives
a painter can use in her compositon: eye level, below eye level and above eye level.
The first four projects have been depicted at an eye-level observation point.
This project will introduce you to below eye-level viewpoint. The most
important aspect to keep in mind is to remain consistent in how all objects
in the composition are depicted. Lines that are straight for eye level will be
curved when positioned below eye level.

Paints

DecoArt Americana Acrylic Paints

| Buttermilk | Sand | Mississippi Mud | Tomato Red | Black Plum |

| Lamp Black | Light French Blue | Deep Midnight Blue | Khaki Tan |

OIL PAINTS

Winton

Titanium White, Raw
Sienna, Permanent
Alizarin Crimson

Shiva Permasol

Permasol Black

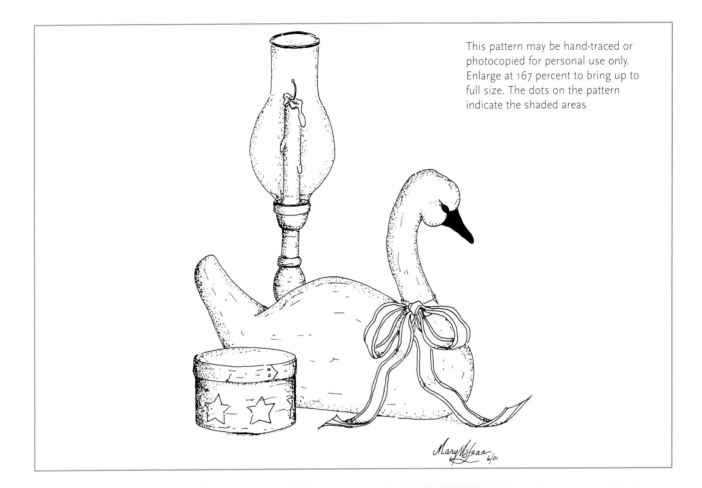

This pattern may be hand-traced or photocopied for personal use only. Enlarge at 167 percent to bring up to full size. The dots on the pattern indicate the shaded areas

Materials

BRUSHES

- Royal Brush Series 2150 nos. 4, 8 and 10 shaders

- Royal Brush Series 2585 no. 10/0 liner

- Winsor & Newton Series 510 nos. 0, 2, 4, 8 and 10 flats

- Winsor & Newton Series 540 no. 10/0 liner

- Ann Kingslan mops nos. 0, 1 and 2

ADDITIONAL SUPPLIES

Sanding disc, tack cloth, wood sealer, sponge brush, sponge roller, water basin, pencil, tracing paper, gray transfer paper, stylus, gray palette, Archival Odourless Solvent, easy-release tape, Krylon Matte Finish 1311

SURFACE

- Wicker star tray from Hofcraft

Acrylic Conversion Chart

If you choose to paint this project entirely with acrylics, consider the following conversions using DecoArt Americana Acrylics.

OBJECT	BASECOAT	LIGHT	HIGHLIGHT	DARK	VERY DARK
Swan	Sand	Light Buttermilk		Yellow Ochre	Honey Brown
Beak	Soft Black				
Box	Light French Blue			French Grey Blue	Uniform Blue
Stars	Buttermilk				
Ribbon	Buttermilk	Light Buttermilk		Honey Brown	
Blue	Light French Blue				
Red	Tomato Red				
Candle	Tomato Red	Cherry Red		Antique Maroon	
Holder	Mississippi Mud	Sable Brown		Bittersweet Chocolate	
Globe	Wash of Mississippi Mud	Light Buttermilk			

Basecoating

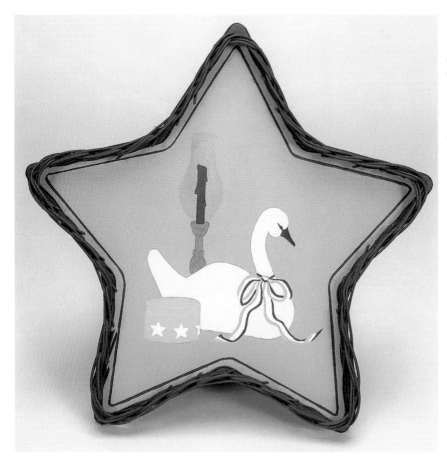

[1] Sand and seal the surface. Apply one coat of Khaki Tan. Sand lightly and apply a second coat of paint. Trace and transfer the basic forms from the pattern. Basecoat the elements with acrylic color, referring to the chart above for color placement. Then transfer details as needed. Paint the inner trim line with Deep Midnight Blue and the outer weave with Black Plum.

Shading

[2] Shade the swan first, using Permasol Black on the no. 4 flat brush. Place the color along the entire edge.

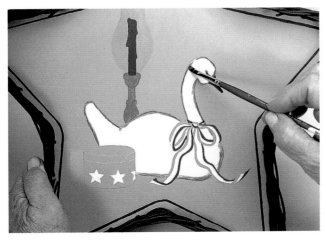

HINT

REFER TO THE PATTERN ON PAGE 68 FOR AN ILLUSTRATION OF THE SHADED AREAS.

[3] Soften the shading with the no. 1 mop to create dimensional form. The light source is from the upper right, so the shading on the left comes further in than that on the right.

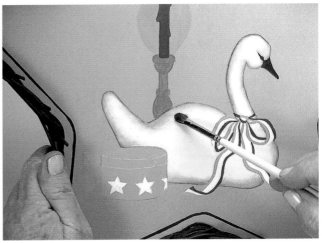

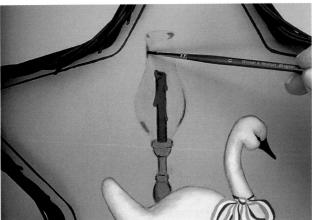

[4] With Permasol Black on the no. 0 flat, block in the shading on the candlestick, candle and glass globe.

HINT

WHEN PAINTING GLASS ON A LIGHT BACKGROUND, IT IS NECESSARY TO DEPICT THE DARKER AREAS THAT EXIST WITHIN THE TRANSPARENT FORM. THE OUTER FORM MUST RETAIN THE CRISP EDGES OF THE GLOBE'S SHAPE.

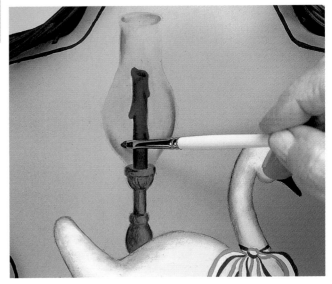

[5] Soften the application with the no. 0 mop.

[6] Shade the sides and rim of the star box with Permasol Black on the no. 8 flat. Note that the light source is from the upper right. The widest area of dark values will exist on the left-hand side of each object. As a sphere in a below eye-level set-up, we see the elliptical shape of the box cover.

Also, lay in a small amount of color to distinguish the separation of the sides and cover.

[7] Work the paint out slightly with the flat. Then soften further with the no. 1 mop.

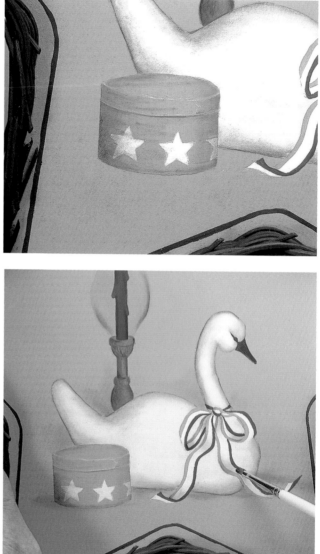

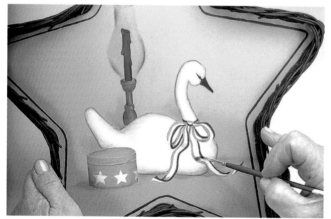

[8] Add atmosphere color to the background with Raw Sienna on a no. 10 flat. Soften with the no. 2 mop. With Raw Sienna + Permasol Black, add some horizontal dark areas to sit the elements on a surface plane. Work the color to establish that the objects are side-by-side. Using Permasol Black on a no. 4 flat, establish a cast shadow of the box on a horizontal surface. Shade the ribbon with Permasol Black on a no. 2 flat.

[9] Soften the shaded areas of the ribbon with the no. 0 mop.

Raw Sienna + Permasol
Black

71

Highlighting

[10] With Raw Sienna + Titanium White, define the edges of the glass globe with the 10/0 liner used for oils. Be particularly careful when rendering the oval at the top as this determines the viewing perspective.

[11] With a mop, soften these lines to the inside of the globe, keeping the outer shape crisp and defined. Turn the piece upside down and see if you need to make any corrections. This will help you to analyze the proper shapes and balance.

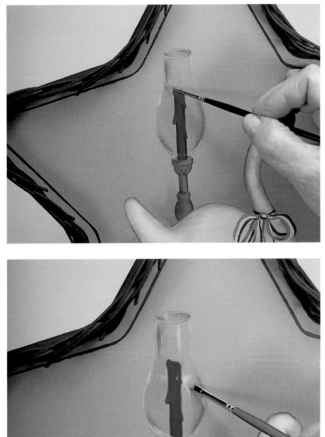

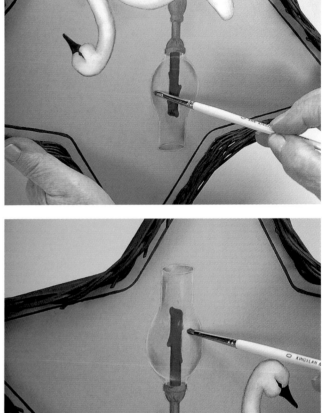

[12] Establish the shines on the glass with the same mix using the no. 2 flat. These primary impact shines will follow the shape of the glass globe.

[13] Soften these shines with the no. 0 mop. With Permanent Alizarin Crimson on the no. 0 flat, place a little reflective color accent on the globe. Reflections will also follow the shape of the recipient. Soften the value change with the no. 0 mop.

Raw Sienna + Titanium White

Aging and Graining

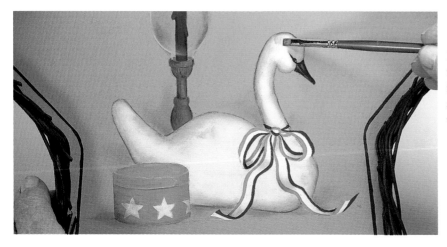

[14] Highlight the beak of the swan with a brush mix of Permasol Black + Titanium White, then soften it with the no. 0 mop. Age the swan a bit by placing a few spots of Raw Sienna on the body; add a few spots to the box as well. Soften with the no. 1 mop.

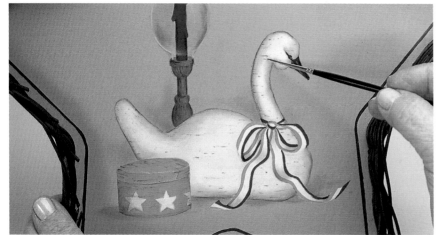

[15] With Permasol Black + Raw Sienna on the liner brush used for oils, create grain markings on the wooden candlestick, the swan and the star box. Establish the pattern according to your perception of the grain. Again, there are many ways to be right.

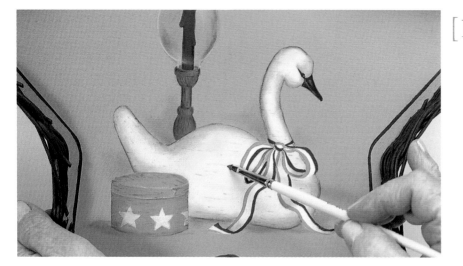

[16] Soften the graining with the no. 0 mop.

Permasol Black +
Titanium White

Final Touches

[17] Bring up the highlights on the glass using the Titanium White + Raw Sienna mix and soften with the no. 1 mop. The size of each additional highlight becomes smaller and lighter until you reach the impasto shine, which is not softened.

[18] Adjust some of the darks on the swan, strengthening until they create the desired form.

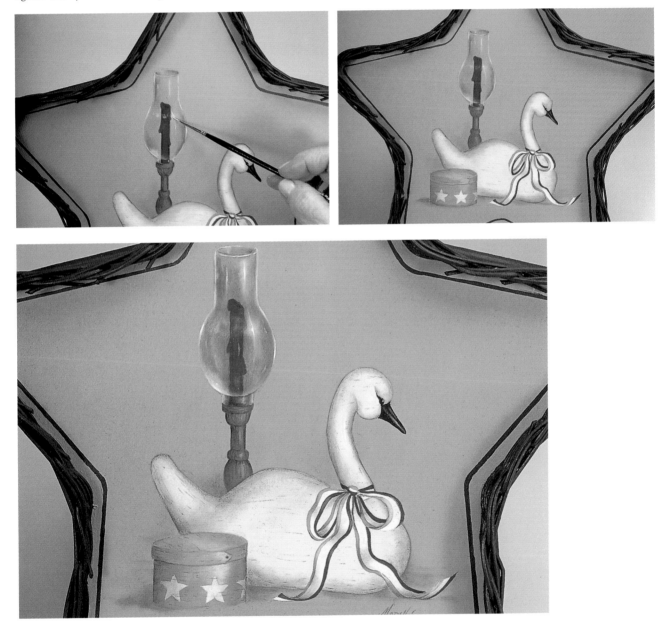

[19] Continue to strengthen the lights and the darks until you're satisfied with the painting. Varnish as directed on page 15.

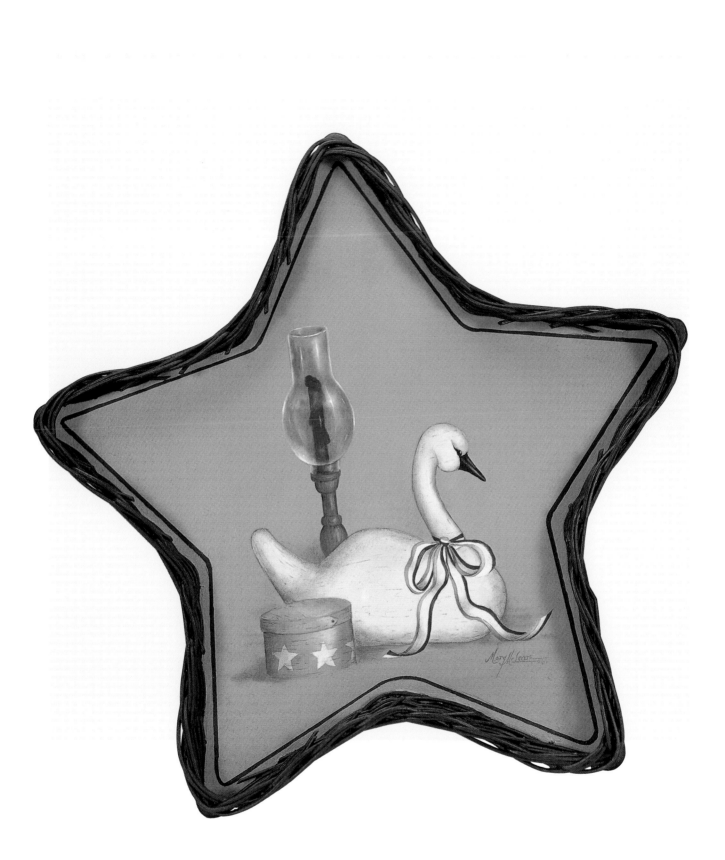

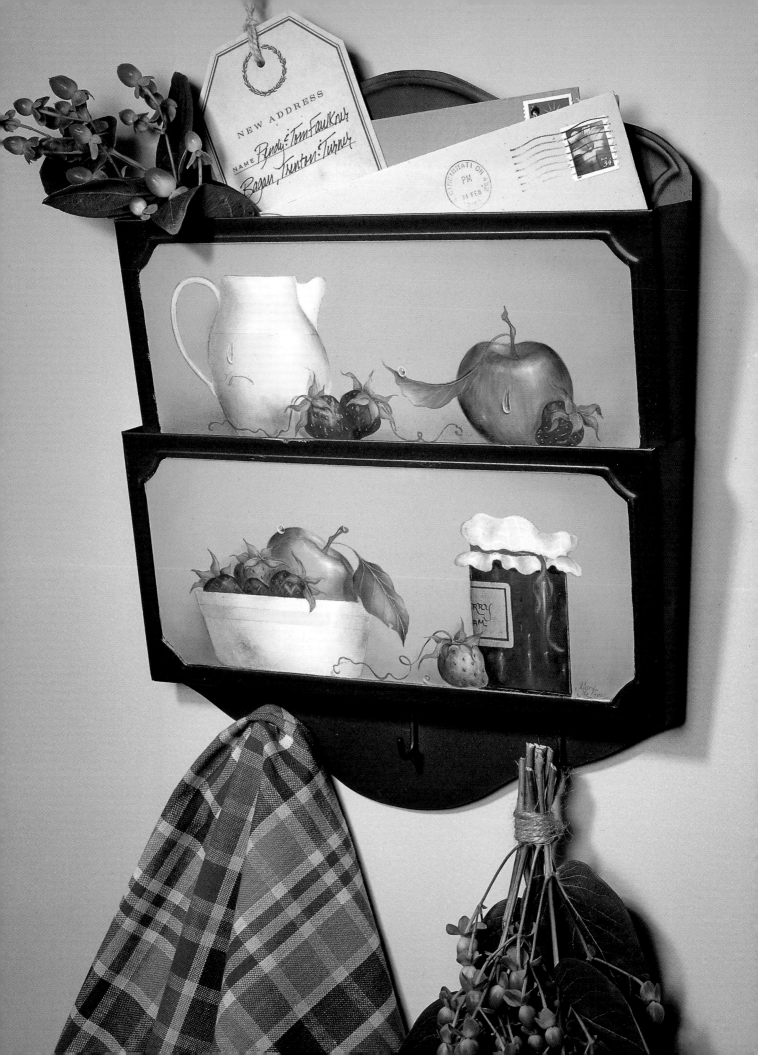

PROJECT SIX

Kitchen Classics

Unexpected details will always add dramatic impact
to a painting. The addition of dewdrops seems to fascinate many viewers.
The viewer is intrigued and wants to explore the painting even further.
When adding dewdrops to a painting, it is important not to overwhelm the project
with these dramatic elements. Draw viewers into one area of the painting. Let them
explore the painting through smaller, less dramatic repetition of dewdrops. These
details should never become the purpose of the painting. They should simply attract
the viewer to the work and provide a sense of reality and wonder.

Paints

DecoArt Americana Acrylic Paints

| Eggshell | Sand | Antique Teal | Country Red | Rookwood Red |

| Hauser Light Green | Hauser Medium Green | Moon Yellow | Arbor Green | Sable Brown |

OIL PAINTS

Winton

Titanium White, Cadmium Yellow Light, Raw Sienna, Cadmium Red Medium, Permanent Alizarin Crimson, French Ultramarine, Ivory Black

Shiva Permasol

Permasol Black, Golden Ochre

Pattern

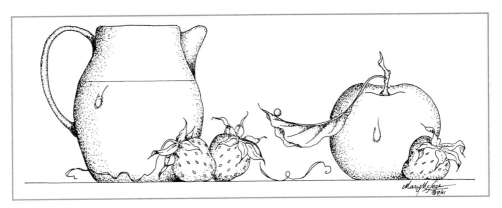

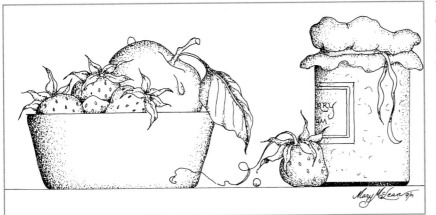

This pattern may be hand-traced or photo-copied for personal use only. Enlarge both patterns at 192 percent to bring them up to full size. The dots on the pattern indicate the shaded areas.

Materials

BRUSHES

- Royal Brush Aqualon Series 2150 nos. 4, 8 and 10 shaders
- Royal Brush Aqualon Series 2585 no. 10/0 liner
- Winsor & Newton Series 510 nos. 0, 2, 4, 6 and 8 flats
- Winsor & Newton Series 540 no. 10/0 liner
- Ann Kingslan mops nos. 0, 1, 2 and 4

ADDITIONAL SUPPLIES

Sanding disc, tack cloth, wood sealer, sponge brush, sponge roller, water basin, pencil, tracing paper, gray transfer paper, stylus, gray palette, Archival Odorless Solvent, easy-release tape, Krylon Matte Finish 1311

SURFACE

- Green mail keeper from Jo C & Co.

Acrylic Conversion Chart

If you choose to paint this project entirely with acrylics, consider the following conversions using DecoArt Americana Acrylics.

OBJECT	BASECOAT	LIGHT	HIGHLIGHT	DARK	VERY DARK
Bowl	Sand	Light Buttermilk	Titanium White	Yellow Ochre	Honey Brown
Stripe	Moon Yellow				
Strawberries	Moon Yellow				
	Country Red	Cherry Red	Taffy Cream		Rookwood Red
	Rookwood Red	Country Red	Cherry Red		Antique Maroon
Seeds	Yellow Ochre				
Strawberry Caps	Hauser Medium Green				
Jar Cover	Moon Yellow	Taffy Cream		Yellow Ochre	
Ribbon	Antique Teal	Teal Green		Deep Teal	
Jam	Slip-slapped Country Red and				
	Antique Maroon				
Apples	Hauser Light Green	Olive Green	Light Buttermilk	Hauser Medium Green	Hauser Medium Green
Stems	Sable Brown	Taffy Cream			
Streaks	Country Red				
Warm Leaves	Hauser Medium Green	Hauser Light Green		Hauser Medium Green	
Cool Leaves	Arbor Green	Green Mist		Deep Teal	

Basecoating

[1] This surface is already prepared with a dark green. There are two painting areas. Tape along the rolled frame to preserve a tidy edge. Apply one coat of Eggshell to each painting area. Sand lightly and apply a second coat of paint. Trace and transfer only the basic forms of the pattern.

Basecoat areas with acrylic color, referring to the chart above for color placement. Then transfer the pattern details.

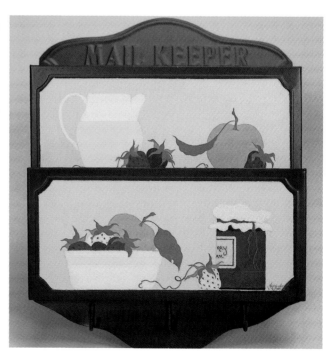

Shading and Initial Highlighting

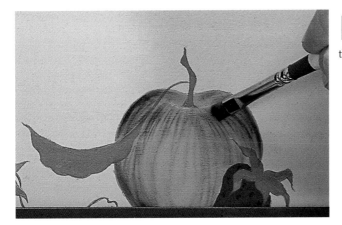

[2] Pick up Permanent Alizarin Crimson on the no. 6 flat. With the chisel edge of the brush, streak in the color on the apple, following the spherical form.

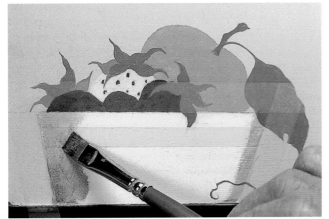

[3] Tape off the edges of the bowl. Lay in the shading on the bowl with Raw Sienna + a touch of Permasol Black on the no. 8 flat. The light source is from the upper right, so the shading on the left side is wider than that on the right.

Raw Sienna + Permasol Black

Permanent Alizarin Crimson + Permasol Black

HINT

REFER TO THE PATTERNS ON PAGE 78 FOR AN ILLUSTRATION OF THE SHADED AREAS.

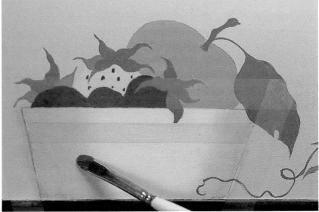

[4] Soften the application with the no. 2 mop.

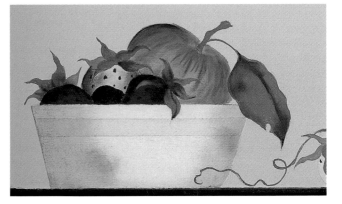

[5] With Permanent Alizarin Crimson on the no. 6 flat, add streaks to the apple in the bowl. With the excess paint left on the brush, add color accents to the bowl, pitcher and leaves. Shade the strawberries with Permanent Alizarin Crimson + a touch of Permasol Black with the no. 4 flat. Soften each of these applications with the no. 1 mop.

[6] Shade the strawberries in the front with Permanent Alizarin Crimson on the no. 4 flat. Tape off the sides of the jar, then shade the jar with Permasol Black on the no. 10 flat. Soften the shading with the no. 2 mop. Remove the tape.

[7] Lay in the shading on the fabric top of the jar with Raw Sienna + just a touch of Permasol Black. Keep this application small so that you can melt it easily into the surrounding value of the fabric.

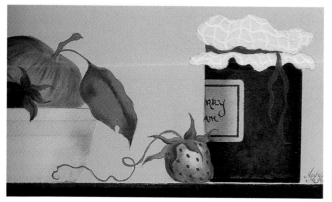

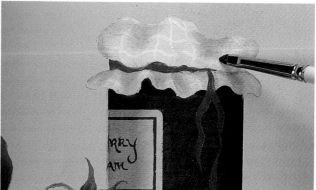

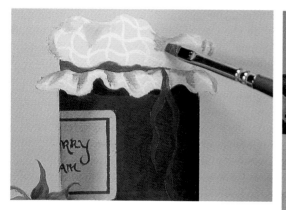

[8] Soften with the no. 1 mop.

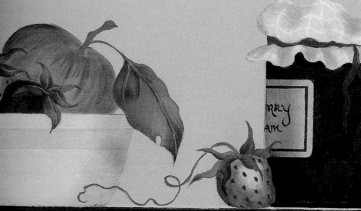

[9] Highlight the leaves and bracts with a light green mix of Titanium White + Cadmium Yellow Light + French Ultramarine. With a lighter, thinned value of this mix, pull veins on the bracts and leaves, following the shape of the leaf. On the larger leaves, pull the center vein, then the side veins with the same mix. Use brushes appropriate for the size of the area in which you're working.

Titanium White +
Cadmium Yellow
Light + French
Ultramarine

Background and Shading

[10] Create a background atmosphere with an application of Raw Sienna behind the elements near the table line in both painting areas. Place Raw Sienna in the upper right and left corners of each painting area as well.

[11] Soften the background with a no. 2 mop.

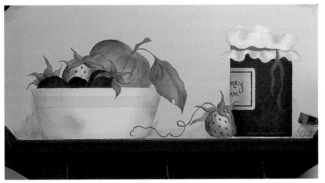

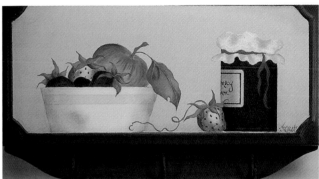

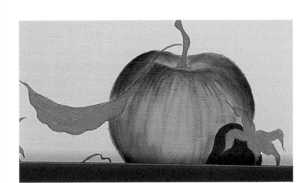

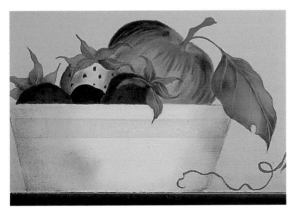

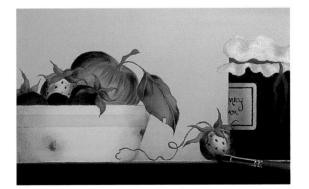

[12] Reinforce the red streaks on the apples using Permanent Alizarin Crimson with the no. 4 flat brush.

[13] Soften the application with the flat brush while maintaining the streaks. While you have some color in the no. 4 flat brush, reinforce the shading on the strawberries, bowl and pitcher. Pick up a bit of Permasol Black for some of the darker strawberries if needed.

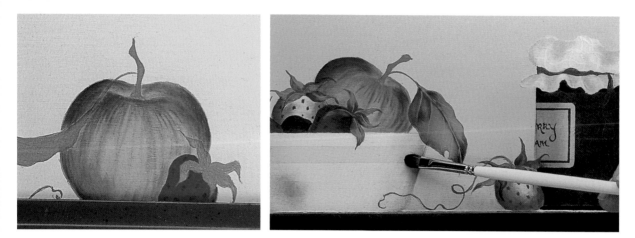

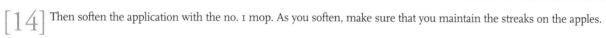

[14] Then soften the application with the no. 1 mop. As you soften, make sure that you maintain the streaks on the apples.

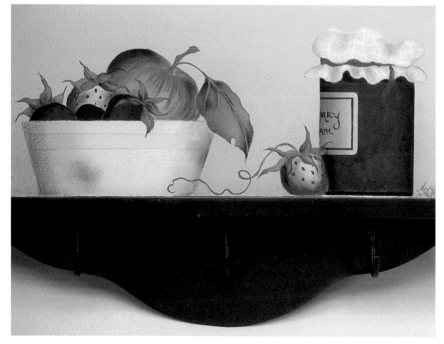

[15] Strengthen the darks again with Raw Sienna + a little Permasol Black. Strengthen the shading on the sides of the bowl, on the leaves and between the strawberries. Then soften the application with the appropriate size mop.

HINT

KEEP IN MIND THAT VALUE
CHANGE CREATES FORM, AND
FORM CREATES THE PERCEP-
TION OF REALITY. AS YOU
SHADE THE ELEMENTS IN A
PAINTING, WORK TO CREATE A
VARIETY OF VALUES.

Highlighting and Cast Shadows

[16] Highlight the leaves and bracts with a light green mix of Titanium White + Cadmium Yellow Light + a speck of French Ultramarine. Use the no. 2 flat.

[17] Soften the application with the no. 1 mop brush. Then, with a thinned version of the same mix, reinforce the veins on the leaves. Highlight the stems with a mix of Raw Sienna + Titanium White. Before proceeding, let the surface dry.

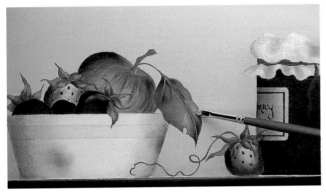

[18] Dampen the highlight area of the apples with Golden Ochre to establish a warm base for highlights. Brush mix Titanium White + a touch of Raw Sienna. Apply this to the highlight area of the apples with the no. 0 flat.

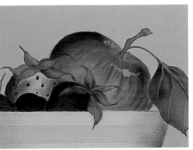

[19] Blend this highlight with the no. 0 mop, following the form of the apple. With the same mix, highlight the glass jar. Place this highlight so it follows the cylindrical form of the jar. With this same mix, highlight the bowl, pitcher, ribbon and fabric cover.

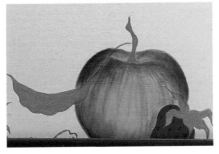

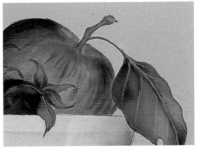

Raw Sienna + Titanium White

[20] On the strawberries, scumble a subtle criss-cross pattern around the seed pocket. Highlight the seeds with Raw Sienna + a speck of Titanium White. Soften all of these applications slightly with the no. 0 mop brush.

[21] Build the highlights with the same mix on the apple. Softly pounce the highlight using the no. 0 mop. Add a final sparkle and let it be.

Using Permasol Black, lay in the shape of the cast shadow of the leaf onto the apple with the no. 4 flat. This shadow will take the form of the stem and leaf, but will follow the shape of the apple. Let the surface dry thoroughly.

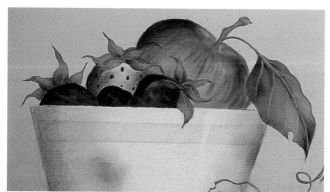

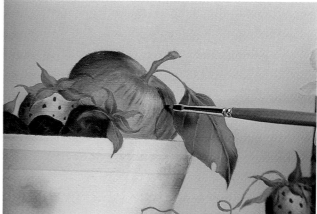

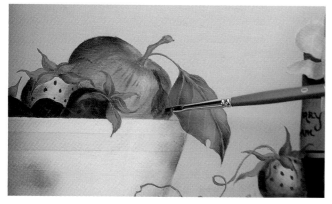

[22] Fill in the shape with Permasol Black on the no. 2 flat.

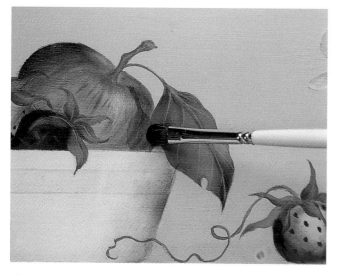

[23] Then soften the shadow with the no. 1 mop.

HINT

SOME SURFACES ALLOW LIGHT TO BE ABSORBED. OTHERS ARE SO HARD THAT THEY REFLECT THE LIGHT BACK TO THE EYE OF THE VIEWER. FINAL SHINES ON A HARD SURFACE ARE NOT DIFFUSED, BUT DEMONSTRATE THE EFFECT OF THE LIGHT ON THE SURFACE.

Dewdrops

[24] Add water drops to enhance the presentation of reality. There are two types of dewdrop that will add reality to your painting. The teardrop-shaped dewdrop is water in motion. The rounded dewdrop is standing water. The procedure is the same for both dewdrops. Remember that here, the light source is coming from the upper right. If the light source is from the left, place the lights in steps 4 and 5 on the opposite side.

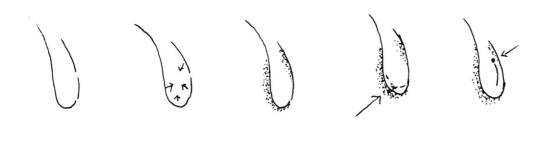

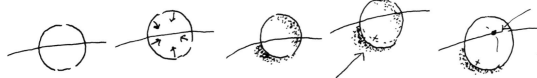

1. Using a no. 10/0 liner brush, outline the shape of the dewdrop with Titanium White + Permasol Black. Be careful not to close the upper part of the teardrop shape. On the rounded dewdrop, note that the surface line will show through the transparent dewdrop.

2. Using a no. 0 flat, soften the paint to the inside of the drop.

3. Using a darker value of the resting surface color, lay in the cast shadow and inside dark. Soften with the no. 0 mop.

4. Using a gray that is slightly darker than in step 1, apply a secondary light at seven o'clock with the no. 0 flat. Soften with the no. 0 mop.

5. Apply a primary light in the upper right with Titanium White. Do not soften this application.

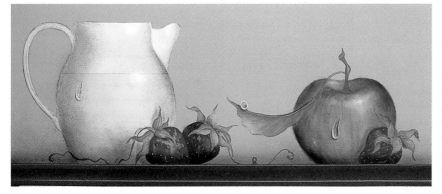

[25] Add dewdrops to the pitcher and apple. Continue to shade and highlight each element until you're satisfied with the result. Add cast shadows from the strawberries onto the pitcher and apple, and from the stem onto the apple.

Final Touches

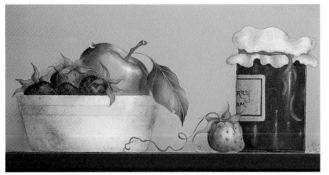

[26] Add dewdrops to the bottom painted section as well. Place cast shadows on the strawberries in the bowl, and a little shadow where the strawberry tendril passes in front of the bowl. Continue to work the shading and highlights until you're satisfied. Varnish as directed on page 15.

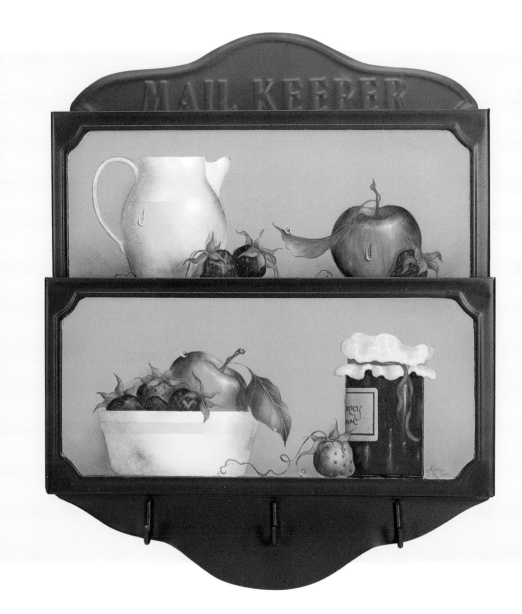

7

Grandmother's Roses

As was discussed on page 19, all colors have a temperature. And colors that are considered warm and cool can even vary in temperature. When painting a group of leaves, consider the possibility that there can be both warm and cool green leaves. Their interaction with the temperature of the background will create depth and dimension. Some leaves will come forward, while others will recede. In this project the background is cool so the warm leaves come forward.

Paints

DecoArt Americana Acrylic Paints

Light Buttermilk	French Vanilla	Moon Yellow	Antique Gold	Gooseberry Pink

Hauser Medium Green	Arbor Green

OIL PAINTS

Winton

Titanium White, Cadmium Yellow Light, Raw Sienna, Permanent Alizarin Crimson, Terre Verte

Shiva Permasol

Permasol Black, Golden Ochre

Pattern and Materials

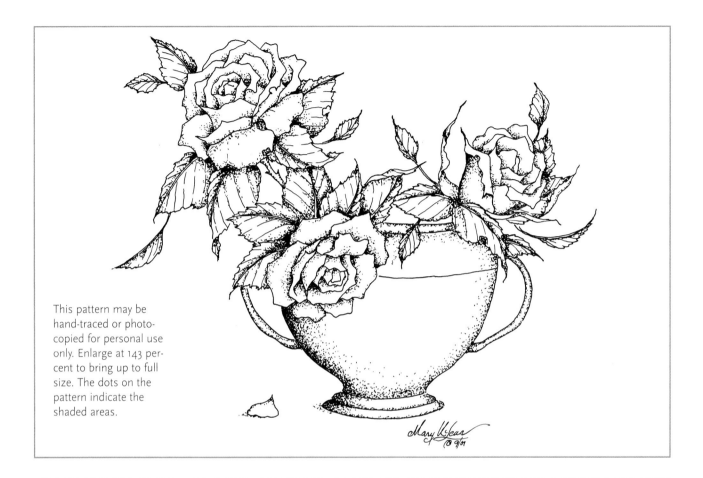

This pattern may be hand-traced or photocopied for personal use only. Enlarge at 143 percent to bring up to full size. The dots on the pattern indicate the shaded areas.

Materials

BRUSHES

- Royal Brush Aqualon Series 2150 nos. 4, 8 and 10 shaders

- Royal Brush Aqualon Series 2585 no. 10/0 liner

- Winsor & Newton Series 510 nos. 0, 2, 4, 6, and 10 flats

- Winsor & Newton Series 540 no. 10/0 liner

- Ann Kingslan mops nos. 0, 1 and 2

ADDITIONAL SUPPLIES

Water basin, pencil, tracing paper, gray transfer paper, stylus, gray palette, Archival Odourless Solvent, easy-release tape, Krylon Matte Finish 1311

SURFACE

- Pillow vase from Auntie M's Porcelain

Acrylic Conversion Chart

If you choose to paint this project entirely with acrylics, consider the following conversions using DecoArt Americana Acrylics.

OBJECT	BASECOAT	LIGHT	HIGHLIGHT	DARK	VERY DARK
Warm Leaves	Hauser Medium Green	Hauser Light Green		Hauser Dark Green	Black Green
Cool Leaves	Arbor Green	Green Mist		Deep Teal	Black Green
Leaf Accents	Crimson Tide				
Front Roses	Gooseberry Pink	Base Flesh		Crimson Tide	
Back Roses	Gooseberry Pink + Light Buttermilk (1:1)	Hi-Lite			
Vase Top	Moon Yellow			Graphite	
Vase Bottom	French Vanilla			Graphite	
Handles and Rim	Antique Gold	Taffy Cream	Light Buttermilk	Honey Brown	
Vase accents	Crimson Tide				

Basecoating

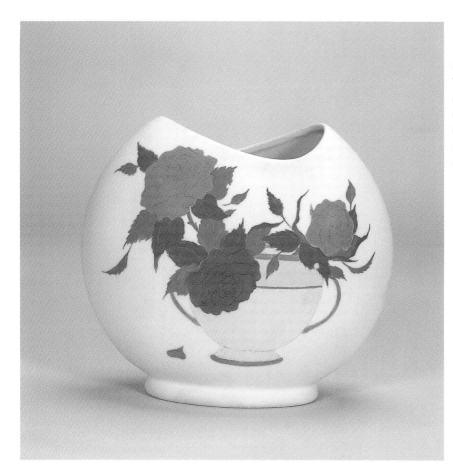

[1] This surface is made of porcelain, and because of the extreme density of porcelain, it is not necessary to seal it. Trace the pattern and transfer the outline of each form onto the surface. Basecoat each element with acrylics, referring to the chart above for color placement. Matte spray the basecoated surface. Apply the details of each object.

Gooseberry Pink + Light Buttermilk (1:1)

Shading

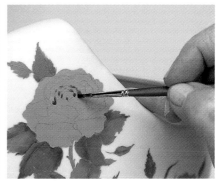

[2] Block in the shading on the leaves to create form. Use the no. 2 flat and Permasol Black. At this stage, place the color in the general area of the shading. In the next step, you can refine the value change.

[3] To blend the color, move out the color with the same flat brush. Create a gradation of value so the shading color melts into the base acrylic. Then soften further with a no. 0 mop.

[4] Shade the roses with a mix of Permasol Black + Permanent Alizarin Crimson on the no. 0 flat. Refer to the pattern for guidance on where to apply these dark values. Work from the center to the outside petals.

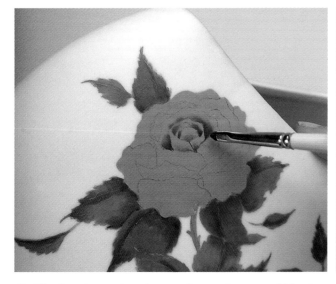

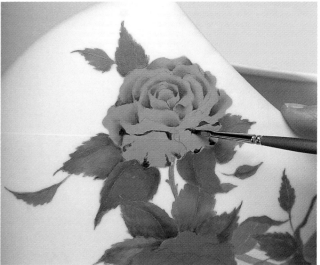

[5] After placing the color on a few petals, stop and blend. Soften the application with a no. 0 mop, following the shape of each petal.

[6] Go back to the no. 0 flat and lay in the color from step 4 for a few more rows of petals. To complete this rose, I stopped several times to blend before continuing to lay in more color.

Permasol Black +
Permanent Alizarin
Crimson

HINT

REFER TO THE PATTERN ON PAGE
90 FOR AN ILLUSTRATION OF THE
SHADED AREAS.

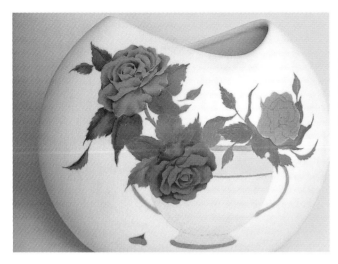

[7] Use the same Permasol Black + Permanent Alizarin Crimson mix and the same technique for the other roses. Note that it is the dark values that really give the roses their form.

Raw Sienna + Permasol Black

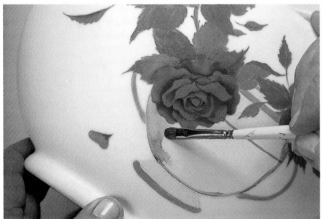

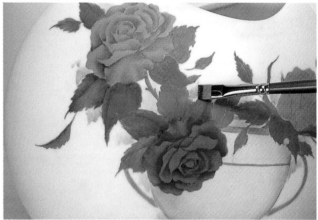

[8] Begin to shade the vase with a mix of Raw Sienna + a touch of Permasol Black. Use the no. 10 flat to apply the color. Then use the no. 2 mop to blend and soften the color into the center of the vase. The light source is from the upper right, so place the widest application of dark on the left side of the vase.

[9] Finish softening the darks on the vase. With Terre Verte on the no. 8 flat, apply the atmosphere color to the background. This will help to transition the background to the objects that rest upon it.

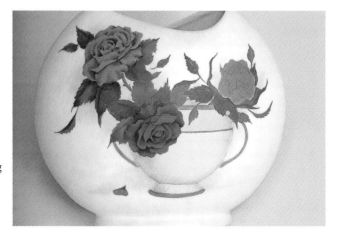

[10] Work out the color with the same flat brush, moving in a circular motion. Then soften with the no. 2 mop. When mopping the green, overlap the edges of the surrounding objects so that the color appears to be coming out from behind the painting. Note: Although the right-hand rose is not painted here, paint it at the same time as the other two roses.

Shading, *continued*

[11] Strengthen the darks on the leaves with a mix of Terre Verte + Permasol Black on the no. 2 flat. Place these applications within the very darkest areas of the leaves. Soften the shading with the no. 0 mop.

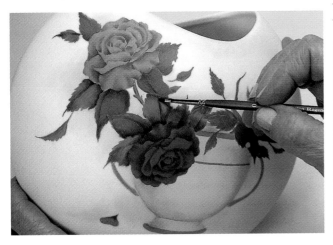

[12] Strengthen the darks in the core areas of the rose, applying the Permanent Alizarin Crimson + Permasol Black mix to just a few rows of petals at a time. Then soften the applications with a no. 0 mop. Here I have applied and softened the center of the rose and am applying the shading to the rest of the form.

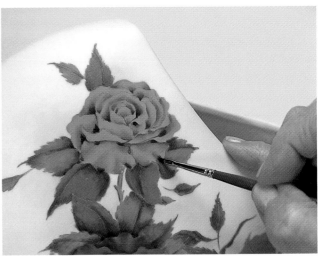

[13] Soften those applications. Use the same technique and colors to complete the other roses.

HINT

THE DENSITY OF PORCELAIN PROVIDES
A VERY HARD SURFACE, WHICH CAN BE
SOMEWHAT SLIPPERY. USE LIGHT PRESSURE
ON YOUR BRUSH TO HELP MAINTAIN CONTROL
OF THE PAINT APPLICATION.

Terre Verte + Permasol
Black

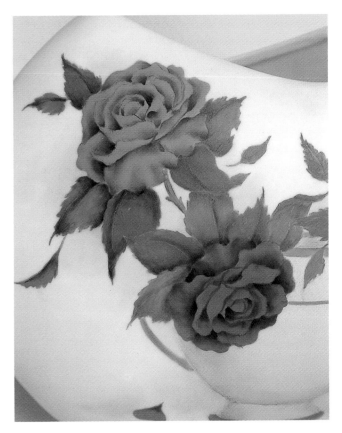

Highlighting

[14] Highlight the leaves with a light green mix of Titanium White + Cadmium Yellow Light + a speck of French Ultramarine. Apply the color with the no. 2 flat, and soften it with the no. 0 mop. Add the veins to the leaves with the liner brush. Use a thinned mix of the highlight value that is slightly lighter than the area on which the veins are placed.

[15] Before beginning the highlights on the roses, dampen the highlight area with Golden Ochre using the no. 4 flat. Place this especially in the center of the flower near the growth point.

Titanium White + Cadmium Yellow Light + French Ultramarine

Titanium White + Raw Sienna

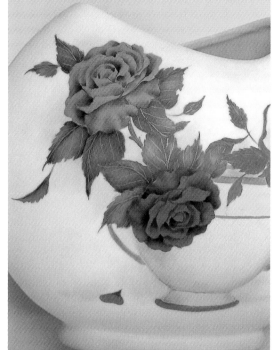

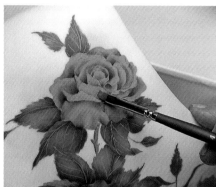

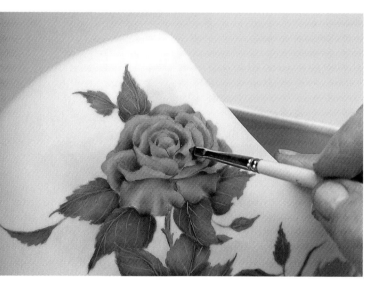

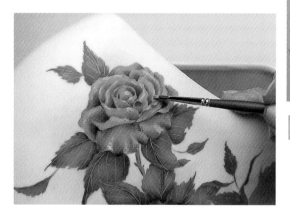

[16] Using a no. 0 flat, lay in the highlight on the rose with a mix of Titanium White + just a touch of Raw Sienna.

[17] Soften and blend out the highlights with the no. 0 mop.

Final Touches

[18] Lay in the highlights on the other roses with the same mix and brush. Then blend out with the no. 0 mop. Reinforce the shading on the vase with Raw Sienna + a touch of Permasol Black using the no. 6 flat and no. 2 mop. Place a touch of Permanent Alizarin Crimson on the bowl to harmonize the colors of the roses with the vase. Repeat these color accents on the leaves as well.

[19] Highlight the vase with Titanium White + a touch of Raw Sienna, scumbling it in with a no. 10 flat. Build the highlight with the same mix but apply in smaller and smaller areas. Pounce the mop and soften each application with a no. 0 mop.

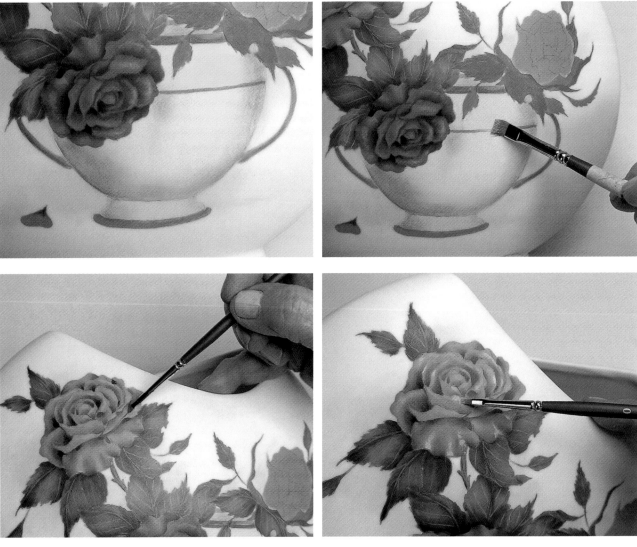

[20] Reinforce the shading in the very dark areas of the roses.

[21] In relationship to these darks, reinforce the highlight areas on the roses.

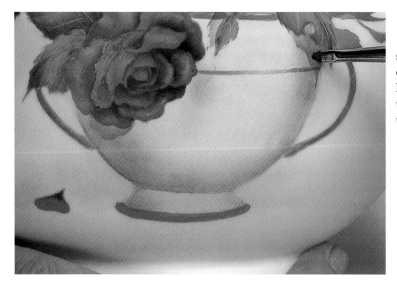

[22] Using Permasol Black, place the cast shadows in relationship to the right hand light source. Those shadows will fall opposite the origin of light. The shadow will be transparent and will follow the shape of the recipient, such as the vase or table. Continue to make any further adjustments, then varnish as directed on page 15.

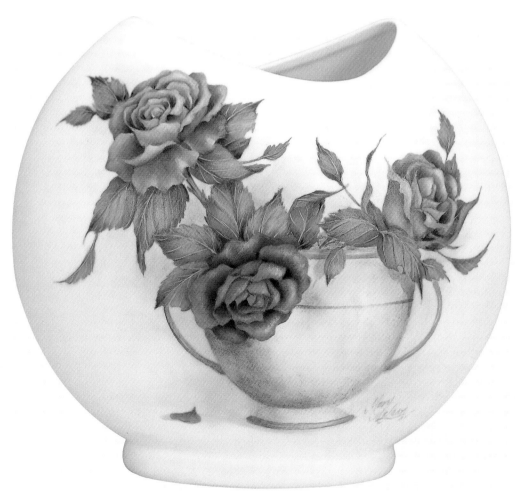

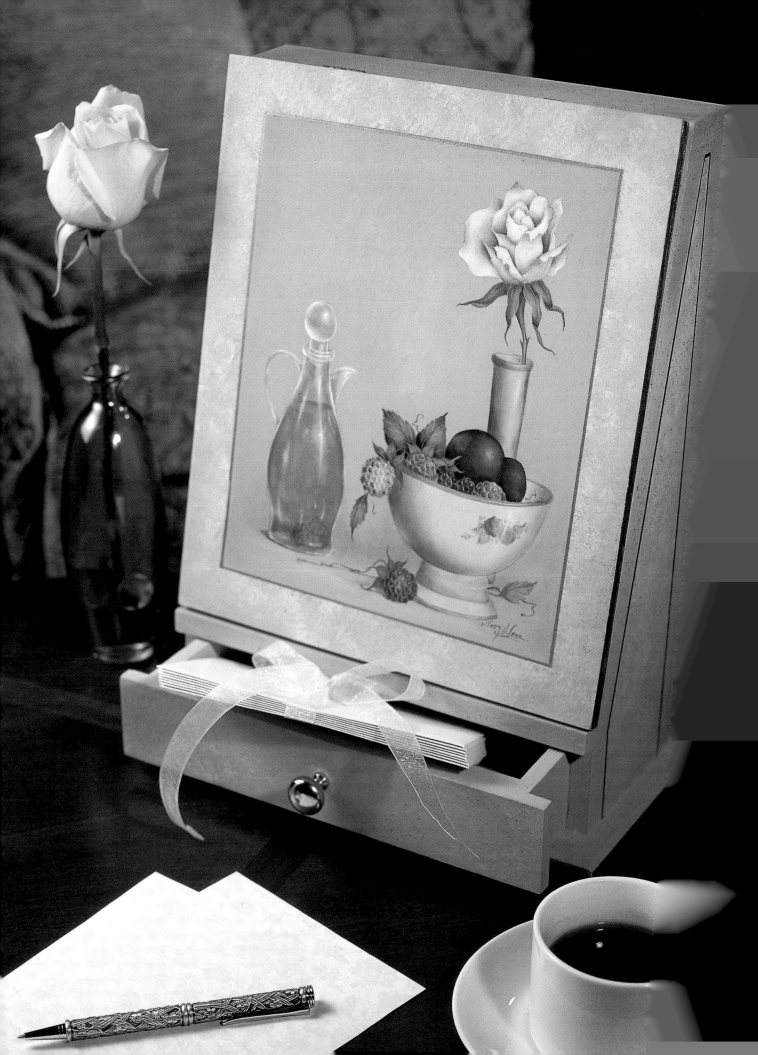

PROJECT EIGHT

Rasperry Vinegar

A focal area is the place within a painting that captures the viewer's eye. In this project the focal point is the bowl of raspberries. This is the brightest element and it draws the viewer into the painting. The bottle of raspberry vinegar and the rose and vase are less dramatic. Notice that color from the focal point is included on these secondary elements to tie the painting together.

Paints

DecoArt Americana Acrylic and Dazzling Metallic Paints

Glorious Gold (Dazzling Metallic)	French Vanilla	Warm Neutral	Deep Burgundy	Camel
Sand	Buttermilk	Antique Mauve	Antique Maroon	Antique Gold
Hauser Medium Green	Arbor Green	Celery Green		
Dove Grey	Neutral Grey			

OIL PAINTS

Winton

Titanium White, Cadmium Yellow Light, Raw Sienna, Terre Verte, Permanent Alizarin Crimson, French Ultramarine

Shiva Permasol

Permasol Black, Golden Ochre

Pattern and Materials

This pattern may be hand-traced or photocopied for personal use only. Enlarge at 200 percent to bring up to full size. The dots on the pattern indicate the shaded areas

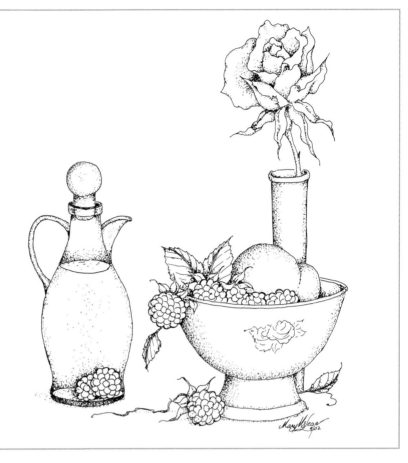

Materials

BRUSHES

- Royal Brush Aqualon Series 2150 nos. 4, 8 and 10 shaders

- Royal Brush Series 2585 no. 10/0 liner

- Winsor & Newton Series 510 nos. 0, 2, 4 and 8 flats

- Winsor & Newton Series no. 10/0 liner

- Ann Kingslan mops nos. 0, 1 and 2

ADDITIONAL SUPPLIES

Sanding disc, tack cloth, wood sealer, sponge brush, sponge roller, water basin, pencil, tracing paper, gray transfer paper, stylus, gray palette, sea sponge, Archival Odourless Solvent, easy-release tape, Krylon Matte Finish 1311

SURFACE

- Upright secretary, item 200-0071, from Viking Woodcrafts, Inc.

Acrylic Conversion Chart

If you choose to paint this project entirely with acrylics, consider the following conversions using DecoArt Americana Acrylics.

OBJECT	BASECOAT	LIGHT	HIGHLIGHT	DARK	VERY DARK
Rose	Sand	Light Buttermilk		Yellow Ochre	Honey Brown
Warm Leaves	Hauser Medium Green	Hauser Light Green		Hauser Dark Green	
Cool Leaves	Arbor Green	Green Mist		Deep Teal	
Rose Vase	French Vanilla	Buttermilk	Light Buttermilk	Camel	Honey Brown
Vase Trim	Antique Gold	Buttermilk			
Plum	Antique Maroon	Santa Red	Dove Grey	Black Plum	
Raspberries	Camel Celery Green Antique Mauve Deep Burgundy				
Bowl	Dove Grey				
Rose on Bowl	Buttermilk + Antique Mauve				
Leaves on Bowl	Hauser Medium Green				
Vinegar	Neutral Grey				
Bottle	Wash of Neutral Grey				

Surface Preparation

[1] Sand and seal the surface. Apply one coat of Warm Neutral. Sand lightly and apply a second coat of the same color. Measure a 1-inch (2.5cm) border around the outside edge of the front panel. Using easy-release tape, isolate this area by placing tape on the inside edge. Using a slightly dampened sponge, dip it into Warm Neutral and then into Sand acrylic paint. Test the texture and value on the palette to make sure that it is the correct consistency.

[2] Press the sponge onto the isolated area, working quickly to create a variegated textured imprint. Continue the sponging all around the isolated surface area. Pick up additional paint as you proceed, always testing the load on the sponge on your palette before applying to the surface.

Measure a 1-inch (2.5cm) border around the sides of the box. Isolate the center with tape and sponge this area as done on the front panel.

Sponge the drawer of the piece as well.

Surface Preparation, *continued*

[3] When the surface is dry, leave the tape in place. Measure 1 1/8-inch in from the edge and place another piece of tape along this line to form the narrow inner border. Using an acrylic liner brush, fill in the area with two coats of Glorious Gold. Do the same for the side panels. See page 111 for a picture of the finished side panels.

Basecoating

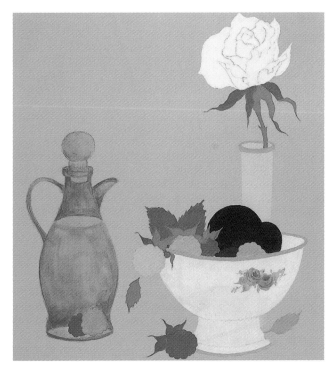

To paint the roses on the bowl, basecoat the flowers with Antique Mauve + Buttermilk. Stroke in the leaves with Hauser Medium Green.

With Antique Mauve define the dark areas, establishing the teacup form of the rose.

Using Antique Mauve + Buttermilk on the liner brush, define the highlights. Follow the spherical form of the flower. Reinforce the dark and tint the green leaves.

[4] Trace and transfer the pattern. Transfer only the basic forms. Basecoat the elements with acrylics, referring to the chart on page 101 for color placement. Follow the instruction at right for painting the decoration on the bowl—keep it light and simple so it does not command attention. Matte spray the surface and lightly transfer the detail separations.

Antique Mauve +
Buttermilk (2:1)

Shading and Accenting

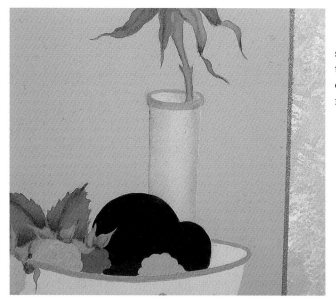

[5] Tape off the sides of the rose vase. Beginning in the center, shade the rose first, using Raw Sienna on the no. 2 flat brush. Develop the form of each petal. Place the color in the corners where the petals overlap. Blend as you go with the no. 0 mop.

HINT

REFER TO THE PATTERN ON PAGE 100 FOR AN ILLUSTRA- TION OF THE SHADED AREAS.

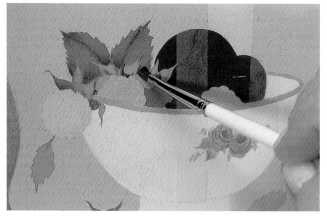

[6] With a mix of Permasol Black + Terre Verte on the no. 0 flat brush, shade the leaves and stem on the rose. Soften with the no. 0 mop.

[7] Use the same mix to shade the raspberry leaves. Soften and blend with the no. 0 mop.

[8] With Raw Sienna on the no. 4 flat, place the shading for the rose vase along the sides and inside the top opening. Then blend with the no. 0 mop and remove the tape.

Permasol Black + Terre Verte

Shading, continued

Permanent Alizarin
Crimson + Permasol
Black

[9] Apply the shading for the plums with a mix of Permanent Alizarin Crimson + Permasol Black with the no. 4 flat. When done, use a little of the paint left in the brush to place reflected color on the vase.

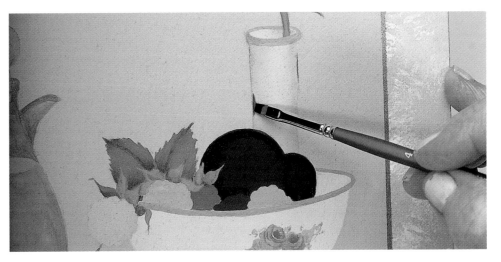

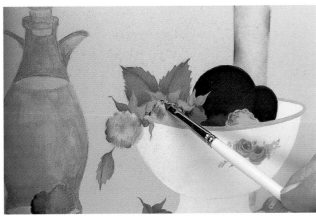

[10] Soften the shading with the no. o mop. With the same brush and mix, apply some color on the raspberries very sparingly. Then blend out with the no. o mop.

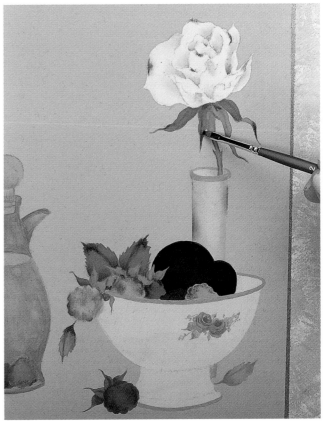

[11] With the same color and brush, apply the color accents to the raspberry leaves, rose leaves and petals.

Raspberries

[12] Soften the accents with the no. o mop. With a thinned light gray mix of Titanium White + Permasol Black + Raw Sienna on the 10/0 liner brush used for oils, create the row of circles on the raspberries. Then begin to soften the application, keeping the composite form of the area.

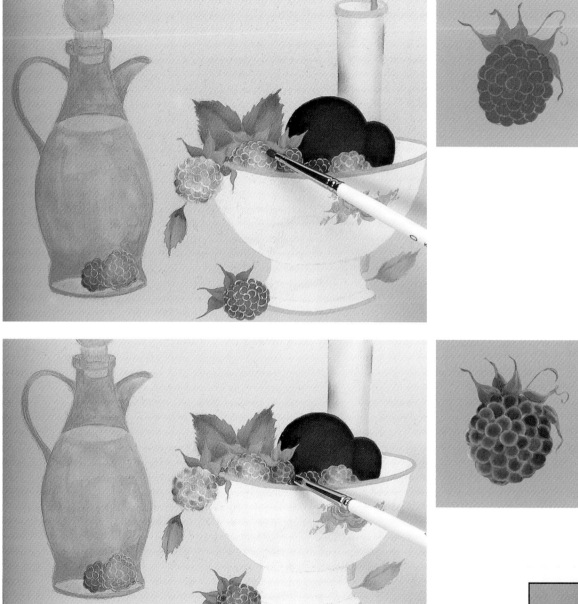

[13] Continue to blend some of the lines. Then with the Permanent Alizarin Crimson + Permasol Black mix, fill in some of the individual sacs using the no. o flat brush. Soften these using the no. o mop in a circular motion.

Titanium White +
Permasol Black + Raw
Sienna

Leaves and Background

Titanium White +
Cadmium Yellow Light +
French Ultramarine

[14] Brush mix a light green with Titanium White + Cadmium Yellow Light + French Ultramarine and highlight all the leaves with a no. 0 flat brush. With the same brush, place some green reflections on the vinegar bottle.

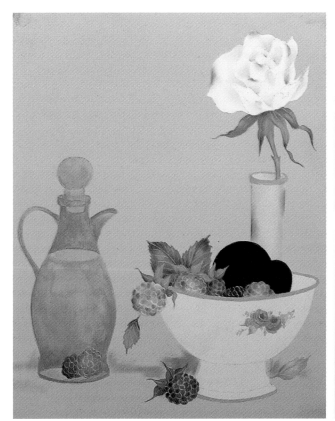

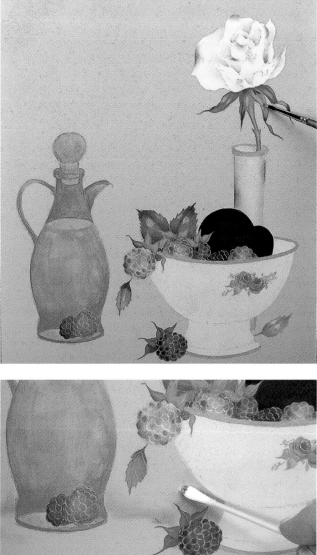

[15] Soften the highlights with the no. 0 mop. Then, add the vein lines with the liner brush, using a thinned, lighter value highlight mix. Let the surface dry thoroughly. With Permasol Black on the no. 10 flat brush, place the atmosphere color around the objects as shown. This application will help to establish a resting surface for the depicted objects. Then pick up Raw Sienna and place in the corners.

[16] Use a paper towel, toilet tissue or a mop to smooth out the Raw Sienna in the corners (the tissue is easier to use in such a large area). Work out the Permasol Black with a cotton swab or mop brush, working in a circular motion.

Shading and Highlighting

[17] Lay in the color for the raspberry vinegar with a mix of Permanent Alizarin Crimson + Permasol Black using a no. 10 flat brush. The color of anything inside glass is always somewhat diffused.

[18] Soften this application with the no. 2 mop.

Titanium White + Golden Ochre

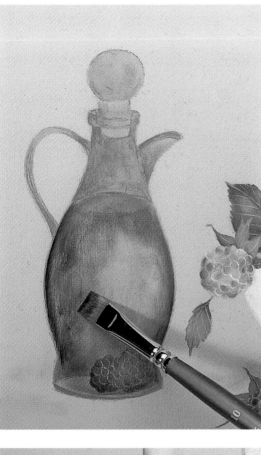

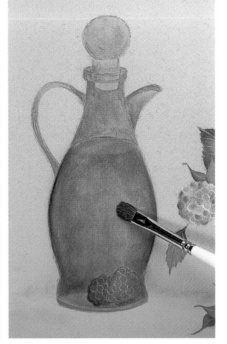

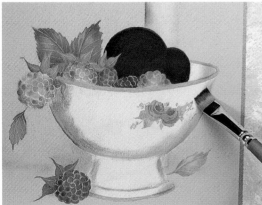

[19] Lay in the shading on the bowl with Permasol Black on the no. 10 flat brush.

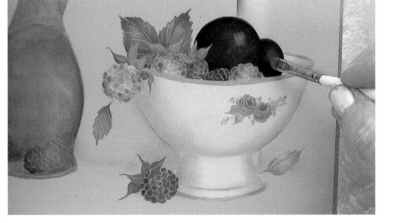

[20] Blend out the shading with the no. 2 mop. To highlight the plums, first warm the highlight area with Golden Ochre using a no. 4 flat. With the same brush, pat in the highlight with Titanium White + Golden Ochre. Soften it by stipple mopping with the no. 1 mop. For this technique, pounce the mop up and down to blend and create a diffused lighter area.

Shading and Highlighting, continued

[21] With a dark mix of French Ultramarine + Cadmium Yellow Light, paint in the tendrils with a liner brush. These tendrils help to anchor the resting berries onto the table surface. Dry thoroughly.

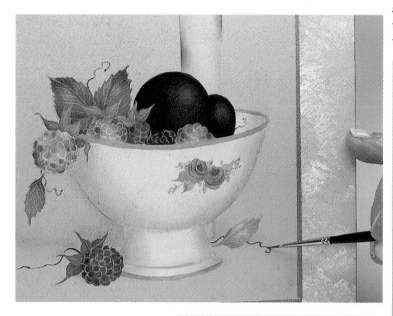

[22] Begin to highlight the jar with a light mix of Titanium White + a bit of Permasol Black + Raw Sienna (light warm gray). Use the liner brush and the no. 0 flat to place the highlight. Begin with the impact of light and then pull it in both directions to follow the form of the surface.

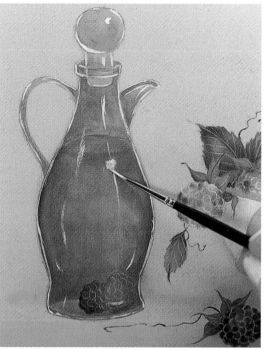

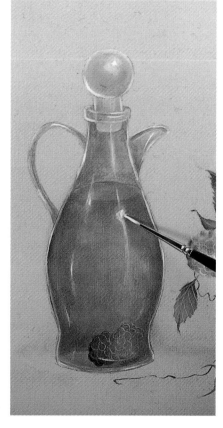

[23] Soften the highlights with the no. 0 mop. Then reinforce some of the highlights using the same mix on the liner brush used for oils.

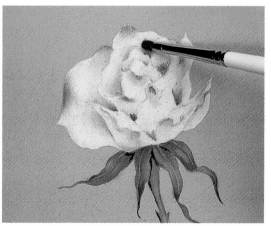

[24] Strengthen the darks on the rose with a mix of Raw Sienna + a touch of Permasol Black. Place the shading in the deepest part of the same areas as previously painted, then begin to soften with the no. 0 mop.

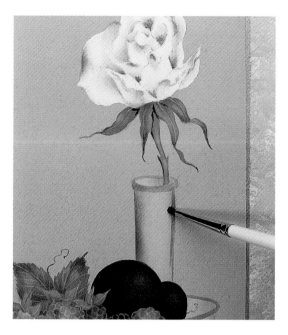

[25] Use the same mix to strengthen the darks on the vase and soften with the no. 1 mop.

Final Touches

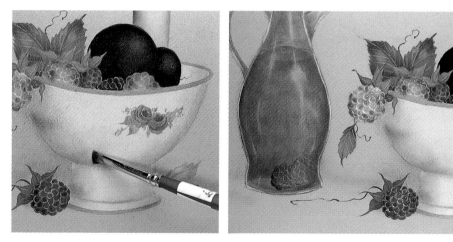

[26] Add accent color to the bowl with a little of the Permanent Alizarin Crimson + Permasol Black mix using a no. 2 flat.

[27] To show that the raspberries have dimension, high-light the sacs in the portion of each raspberry that is closest to the light source. Use the mix of Titanium White + a touch of Permasol Black + a touch of Raw Sienna and the liner brush for this application. Highlight the areas of the sacs that would be hit by the light source. Also, apply a secondary light at seven o'clock on the sac. Soften this application. This light will not be as strong as the primary light source.

Final Touches, continued

[28] With Permasol Black on the liner brush, place the cast shadow for the tendril and the vinegar jar. These shadows will fall upon the form of the table surface.

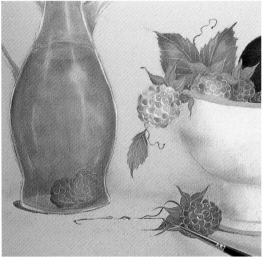

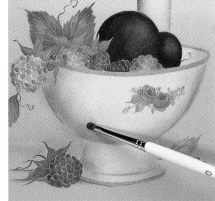

[29] Soften the shadow with the mop. Strengthen the shading on the bowl with Permsol Black on the no. 10 flat. Place the color right over the accent colors. They will show through the very transparent black. While the shading is still wet, add the secondary lights (bounce-back shines) on the left side of the bowl with a no. 4 flat. Use a very sparse amount of Titanium White.

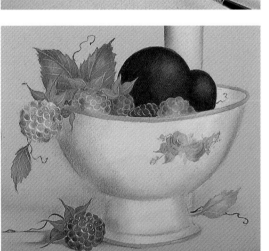

[30] Using a mix of Titanium White + Raw Sienna, apply the highlight to the rim and bowl. Light will follow the form it is cast upon. Build gradually smaller highlights to demonstrate a strong shine. Soften with no. 1 mop.

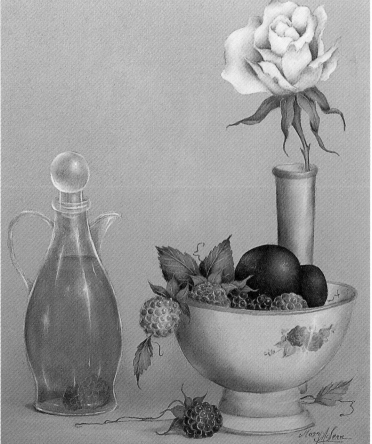

[31] Complete the final shading and highlights. The focal area contains the strongest value changes within the painting. Make sure that the vinegar bottle does not outshine the bowl and its contents. Varnish as directed on page 15.

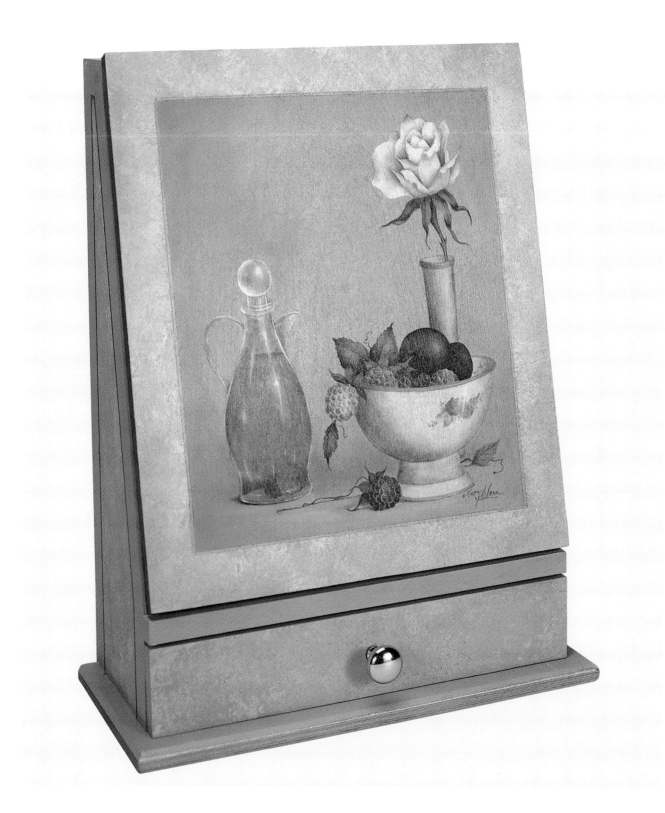

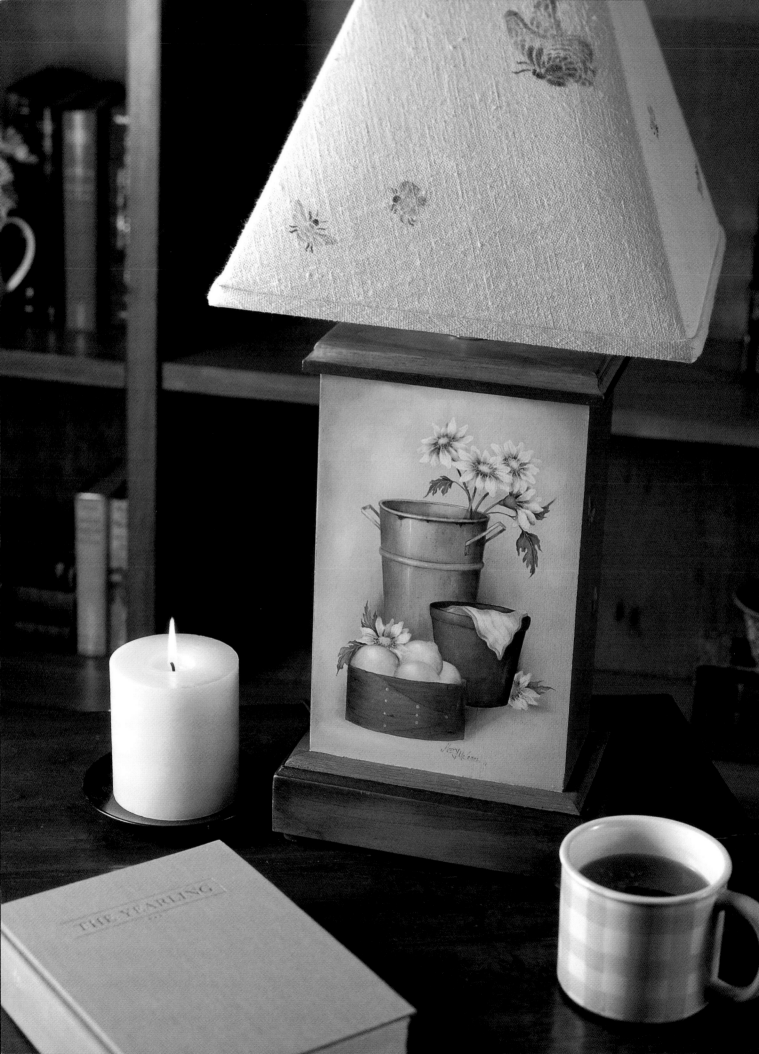

9

The Simple Life

As you study and then paint this final project, consider all
the elements of realism discussed in this book. Identify the basic shapes of each ele-
ment; the light source of the composition; and the perspective of the painting. Think
about how the viewer enters the painting and what the focal point is. Notice the ele-
ments that enhance the realism, like cast shadows. The ability to spot these elements in
other paintings will only make your own realistic paintings better.

Paints

DecoArt Americana Acrylic Paints

Sand	Buttermilk	Light French Blue	Heritage Brick	Cadmium Yellow
Lemon Yellow	Yellow Light	Williamsburg Blue	Hauser Medium Green	Arbor Green
Dove Grey	Neutral Grey	Mississippi Mud		
Raw Sienna	Burnt Umber			

OIL PAINTS

Winton

Titanium White, Cadmium Yellow
Light, Raw Sienna, French
Ultramarine, Cadmium Red
Medium, Permanent Alizarin
Crimson, Ivory Black

Shiva Permasol

Permasol Black, Golden Ochre

Pattern and Materials

Materials

BRUSHES

- Royal Brush Series
 2150 nos. 4, 8 and 10 flats

- Royal Brush Series
 2585 no. 10/0 liner

- Royal Brush Series 1112 stencil
 brush

- Winsor & Newton Series
 510 nos. 0, 2, 4, 6 and 10 flats

- Winsor & Newton Series
 540 no. 10/0 liner

- Ann Kingslan mops
 nos. 0, 1 and 2

ADDITIONAL SUPPLIES

Sanding disc, tack cloth, wood
sealer, sponge brush, sponge
roller, pencil, tracing paper,
gray transfer paper, stylus, gray
palette, Archival Odourless
Solvent, Krylon Matte Finish
1311, easy-release tape, 1-ply
toilet tissues, cotton swabs, paper
towel, Butterflies & More stencil
from Delta

SURFACE

- Lamp, item 102-9041, from
 Viking Woodcrafts, Inc. Lamp
 shade available from discount
 department stores.

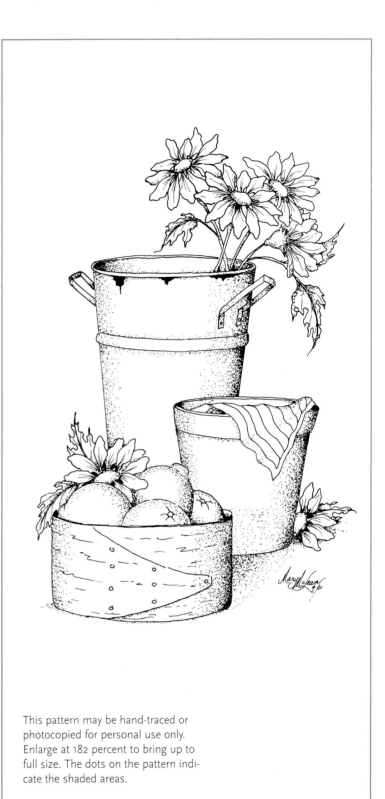

This pattern may be hand-traced or
photocopied for personal use only.
Enlarge at 182 percent to bring up to
full size. The dots on the pattern indi-
cate the shaded areas.

Acrylic Conversion Chart

If you choose to paint this project entirely with acrylics, consider the following conversions using DecoArt Americana Acrylics.

OBJECT	BASECOAT	LIGHT	HIGHLIGHT	DARK	VERY DARK
Metal Container	Light French Blue	Winter Blue		French/Grey Blue	Graphite
Rust	Raw Sienna				
	Burnt Umber				
Daisies	Buttermilk	Light Buttermilk		Graphite	
Centers	Yellow Light	Pineapple	Buttermilk	Raw Sienna	
Leaves	Hauser Medium Green	Hauser Light Green		Hauser Dark Green	Black Green
Pot	Heritage Brick	Gingerbread		Antique Maroon	Graphite
Cloth	Sand	Light Buttermilk		Yellow Ochre	
Design on Cloth	Light French Blue				
	Cadmium Yellow				
Box	Mississippi Mud	Sable Brown		Bittersweet Chocolate	Graphite
Lemons	Lemon Yellow	Buttermilk	Light Buttermilk	Yellow Ochre	
	Cadmium Yellow	Buttermilk	Light Buttermilk	Yellow Ochre	
	Yellow Light				
Leaves	Arbor Green	Green Mist		Deep Teal	Black Green
Shadows	Graphite				

Basecoating

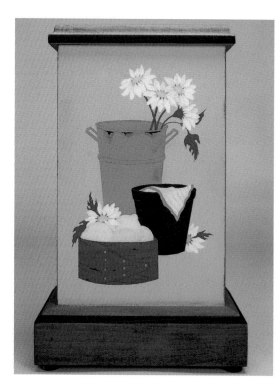

[1] Sand and seal the surface. Mix odorless cleaner with Burnt Umber oil paint to a stain consistency. Apply it to the top and base of the lamp. Using tissues or paper towels, wipe off excess paint. Let the surface dry completely. Trim the edges with Williamsburg Blue and Heritage Brick.

Apply one coat of Dove Grey to the front panel of the lamp. Apply one coat of Neutral Grey to the other three sides. Sand lightly and apply a second coat of acrylic. Trace and transfer the pattern and apply to the front panel of the lamp.

Transfer only basic forms. Basecoat the elements with acrylics, referring to the chart above for color placement. Retransfer details as needed. Apply the acrylic basecoats in the designated areas.

Shading

[2] Tape off the edges of all the containers. Apply the shading with the Permasol Black with the nos. 4 and 10 flat brushes. Always use the appropriate size brush for the area of application. The darkest area of each container will be the side that is the most distant from the light source; in this case, the right side is the darkest side.

[3] Soften the shading with a mop brush that fits the area in which you are working. I used nos. 1 and 2. Use your smallest flats and mops to shade tiny areas such as the handles of the bucket.

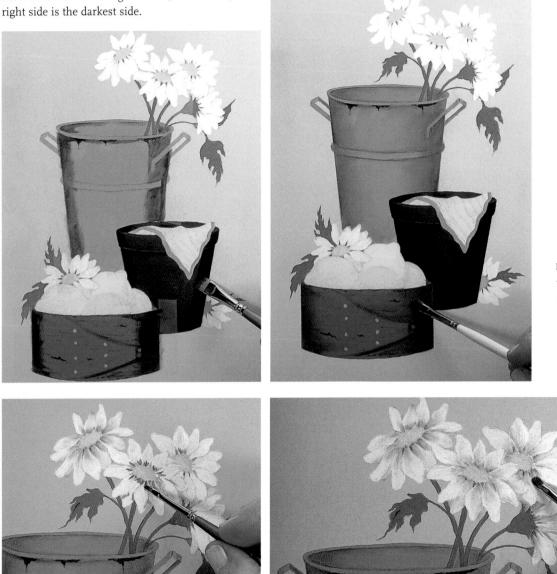

HINT

REFER TO THE PAT-
TERN ON PAGE 114
FOR AN ILLUSTRA-
TION OF THE
SHADED AREAS.

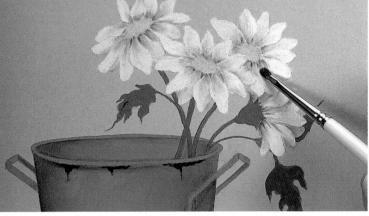

[4] With Permasol Black on the no. 0 flat, apply the shading color near the growth point of each petal, one daisy at a time.

[5] With the no. 0 mop, pull streaks from the center out onto the petal and soften the application. Complete both stages on all the daisies.

[6] Apply the shading to the leaf with Permasol Black on the no. 0 flat brush. Then blend out the color with the no. 0 mop.

[7] With Permasol Black on the no. 4 flat, apply the shading to the towel in the pot. There are many ways to be right with fabric, so place the color wherever you feel it would create nice folds.

[8] Soften the application with the no. 0 mop, creating a variety of folds in the fabric.

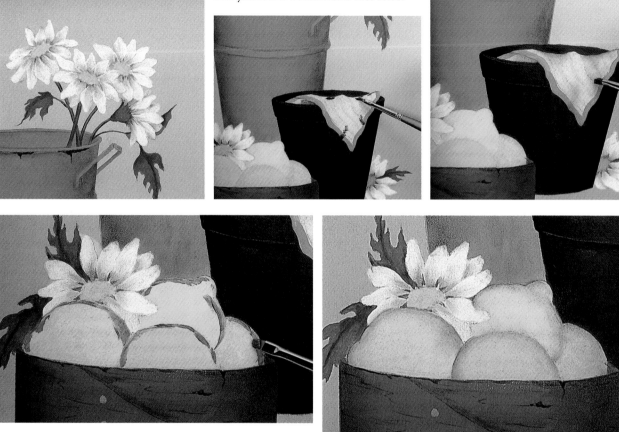

[9] With Raw Sienna + Permasol Black + a speck of Cadmium Red Medium, apply the shading color to the lemons with the no. 2 flat brush. Remember that the widest area of dark exists at the point most distant from the light source. The light on the lemon comes from the same light that impacts the containers.

[10] Soften the shading on the lemons with the no. 0 mop.

Raw Sienna + Permasol Black + Cadmium Red Medium

117

Age Spots and Background

[11] Using the no. 2 flat brush, add age spots of Raw Sienna to the sap bucket and pot, and soften with the no. 1 mop. These spots follow the surface flow of each container. Try to create variety in size and placement. The sap bucket will accept color reflections from surrounding objects as well. So, if desired, add color accent reflections with Permanent Alizarin Crimson and Cadmium Yellow Light. Dry thoroughly.

[12] With Permasol Black on the no. 10 flat brush, place the background atmosphere color to set the elements into the scene. Place this color in the outer corners and behind objects. Add cast shadows to establish a resting area for the containers. The light source originates from the upper left, therefore the cast shadows fall opposite the source and will follow the surface of the table. These additions will give the scene a sense of placement.

[13] Soften the applications with the no. 2 mop, pulling the color in the corner along the outer edge of the surface. You may also soften the application with a cotton swab or tissue. Block in some lighter areas in the background and tabletop with Raw Sienna + Titanium White. Apply it in front of the lemon box and work from side to side to establish the surface form.

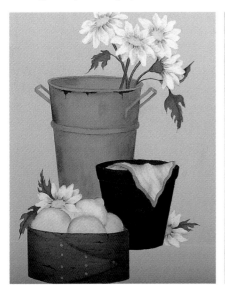

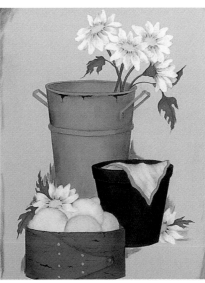

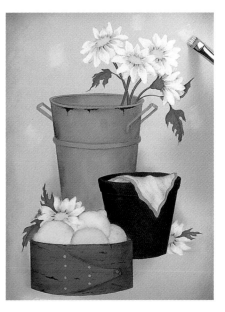

Raw Sienna + Titanium White

[14] Soften these applications with the no. 2 mop. If you have enough paint on your mop, establish the highlight on the sap bucket. With Raw Sienna + Titanium White on the no. 6 flat, add highlights to the other containers as well. Soften with the no. 2 mop.

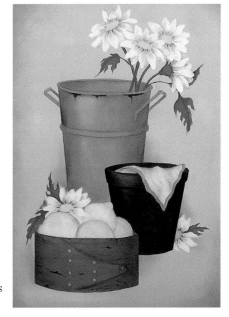

Shading and Highlighting

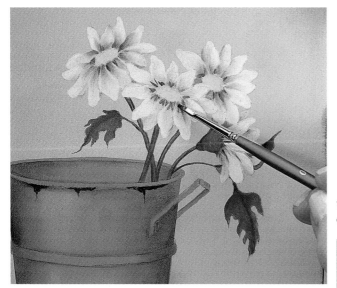

Titanium White +
Cadmium Yellow Light

[16] With Raw Sienna + Permasol Black + a speck of Cadmium Red Medium, shade the center of the daisies using the no. 0 flat brush. Place this color along the lower edge of the center. Then soften it with the no. 0 mop.

[15] Strengthen the darks on the daisies, applying more color at the growth point and blending one daisy at a time. Use Permasol Black on the no. 0 flat and soften with the no. 0 mop.

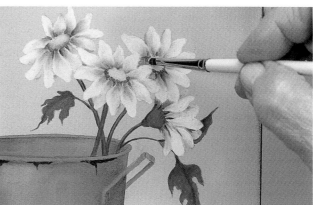

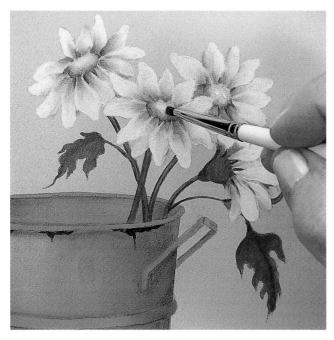

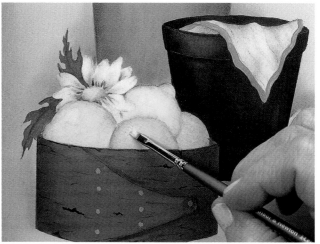

[17] Highlight the centers with Titanium White + a speck of Cadmium Yellow Light on the no. 2 flat. Soften with the no. 0 mop.

[18] With more yellow in the previous mix, highlight the lemons on the upper left side. To blend the highlight and add texture, stipple mop the application. To do this, hold the mop brush perpendicular to the surface and pounce as if you were stenciling the application.

Highlighting

Titanium White +
Cadmium Yellow Light +
French Ultramarine

Cadmium Yellow Light +
French Ultramarine +
Permasol Black

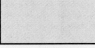

Titanium White + Raw
Sienna

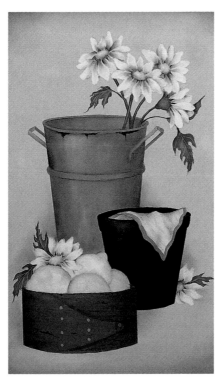

[19] Highlight the leaves with a mix of Cadmium Yellow Light + French Ultramarine on the no. 0 flat. Soften these highlights with the no. 0 mop. Lighten the mix slightly with Titanium White and lay in the veins with the liner brush used for oils. Starting at the growth point, lay in the center vein first then pull the side veins from the center to the outside edge.

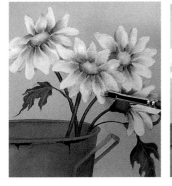

[20] Highlight some of the daisy petals with Titanium White + a little Raw Sienna. This is a very subtle highlight.

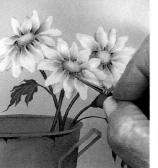

[21] With the same highlight mix, crisp up the edges of the petals using the liner brush. With Permasol Black on the liner, darken the negative spaces between the petals. Apply just a sparse amount of color and do not soften with a mop.

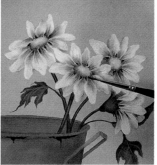

[22] With the paint that's left on the liner brush, pull faint ridge lines on each petal. Begin at the growth point and pull out onto the petal.

[23] With any palette mixes, add pollen dots around the lower edge of the daisy centers. Here I've used mixes of Cadmium Yellow Light, Burnt Umber and Titanium White.

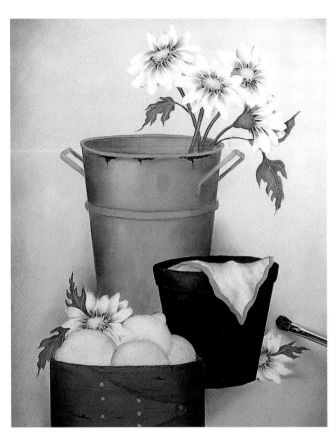

[24] Strengthen the darks on the sap bucket with Permasol Black on the no. 10 flat. Darken under the fabric and on the edges of the wooden box as well. Reinforce some of the background atmosphere, too, in order to allow the elements to stand out from the background. Soften these applications with the no. 2 mop.

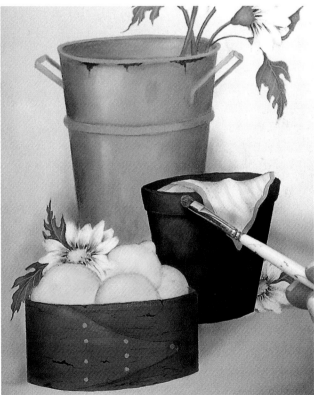

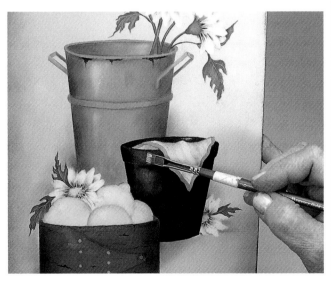

[25] Strengthen the highlights on the sap bucket with Titanium White + Raw Sienna. For the flower pot and wooden box, warm and moisten the highlight area with Golden Ochre first. Then, using the no. 4 flat, place the highlight color on top of the moist basecoat.

[26] Blend out the highlights with the no. 1 mop brush. Add texture to the highlights by stipple mopping the lemon and the pot.

Cast Shadows and Final Touches

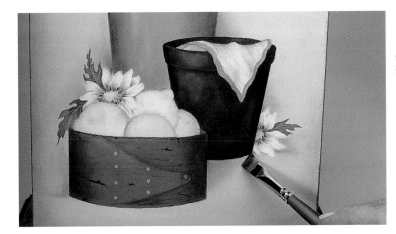

[27] Using the no. 10 flat, establish the form of the cast shadow with Permasol Black. The cast shadow of the box will fall across the surface of the table opposite the light source.

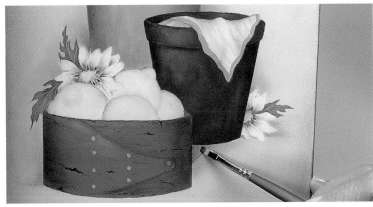

[28] Apply a darker area of the cast shadow to show the value change within the application.

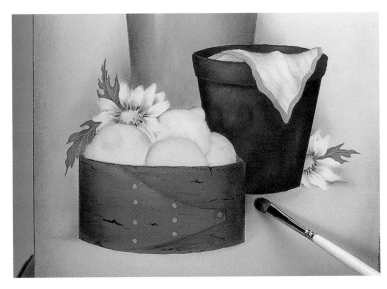

[29] With a no. 1 mop, soften the value change.

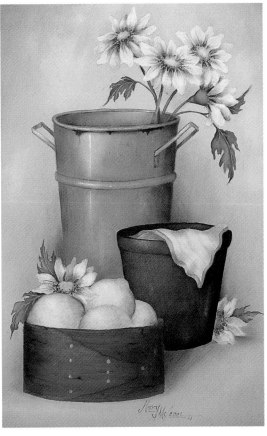

[30] Evaluate the painting. Reinforce the final darks and lights.

Stenciling

[31] If you would like to stencil bees and butterflies on the shade and the other sides of the lamp, tape off any nearby elements on the stencil. Then tape the stencil in place.

[32] To load a stencil brush, dip it lightly into the Ivory Black oil paint.

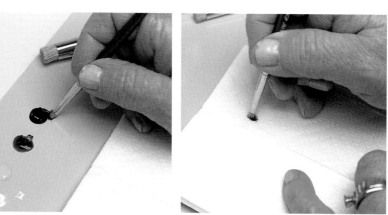

[33] Then unload it on a paper towel, wiping of the excess paint from the brush.

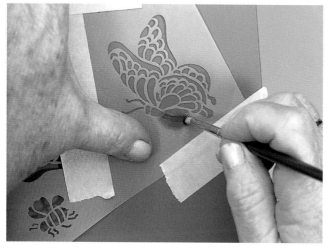

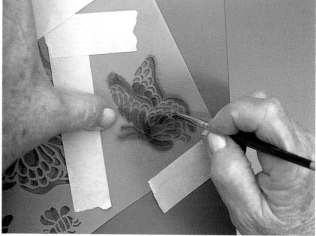

[34] Working from the outside in, stencil the paint on the body of the butterfly by moving the brush in a circular motion. Hold the edges of the stencil tightly in the area in which you're working to ensure a nice crisp edge.

[35] Without cleaning the brush, pick up some French Ultramarine + a touch of Titanium White. Continue to stencil the other parts of the butterfly, picking up more French Ultramarine + Titanium White as you go. Lift the stencil now and then to make sure your colors are showing on the gray background.

Stenciling, continued

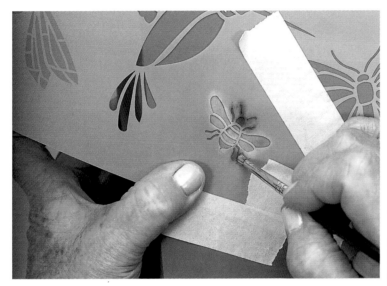

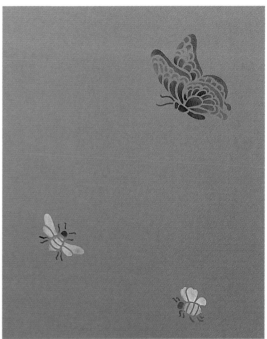

[36] For the bee, stencil the body with Cadmium Yellow Light + touch of Titanium White. Wipe the brush on the paper towel and pick up more Titanium White for the wings. Then work with Ivory Black for the legs and head. Don't clean the brush between colors, just wipe it a bit on the paper towel.

[37] Complete the other bee in the same way. Then stencil some more bees on the sides of the lamp base.

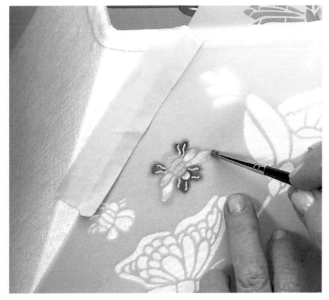

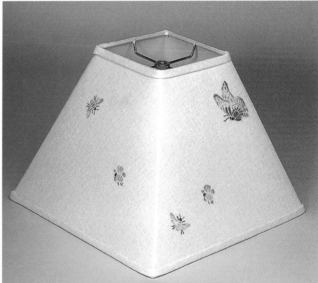

[38] Stencil some bees and butterflies on the lampshade as well. Use the same technique as on the lamp base, but for the bee wings, use a light gray to show up on the white surface. Stencil only the outer edge to suggest the transparency of the wings.

[39] Continue to stencil some bees and butterflies on all sides of the lampshade. Varnish the base of the lamp as directed on page 15. There's no need to protect the paint on the shade.

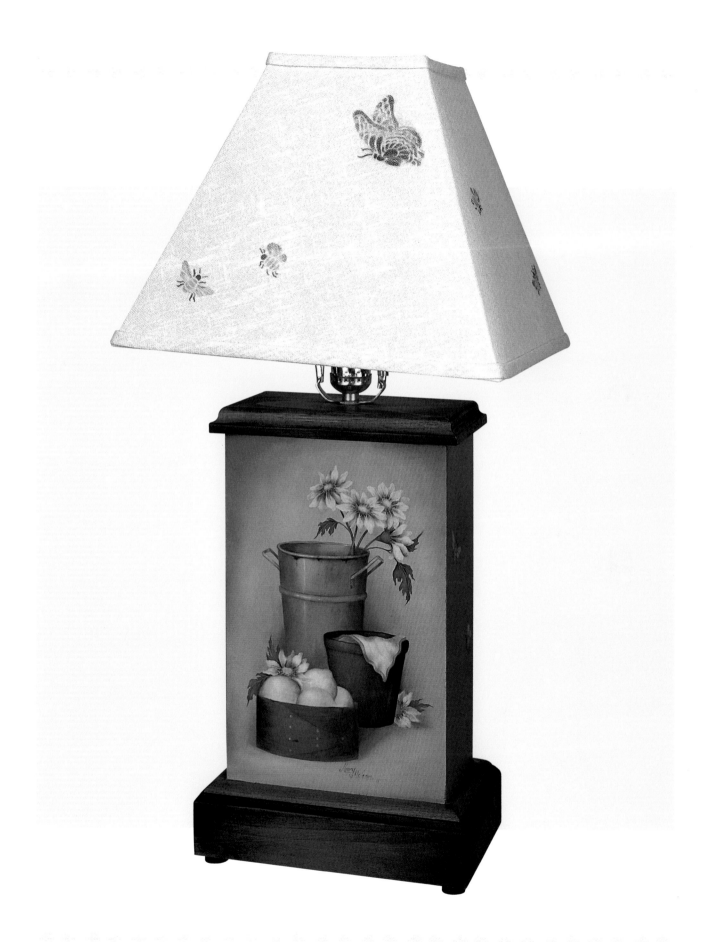

Resources

PAINTS

DecoArt, Inc.
P.O. Box 386
Stanford, KY 40484
(800) 367-3047
www.decoart.com

Hofcraft
(for Shiva Permasol colors)
P.O. Box 72
Grand Haven, MI 49417-0072
(800) 828-0359
www.hofcraft.com

Quarry House Distributors
(for Shiva Permasol colors)
29 River Road Unit 2
Bow, NH 03304
(800) 752-5440

Winsor & Newton
P.O. Box 1396
Piscataway NJ 08855
(732) 562-0770
www.winsornewton.com

BRUSHES

Royal & Langnickel Brush Manufacturing
6707 Broadway Ave.
Merrillville, IN 46410
(219) 660-4170
www.royalbrush.com

Kingslan & Gibilisco Publications
902 South 107 Ave. #102
Omaha, NE 68114
(402) 397-0298
www.kingslan.com

SURFACES

Auntie M's Porcelain
417 Mercury Ave.
Salina, KS 67401
(800) 498-3893
e-mail: dmhoesli@midusa.net

Bush's Smoky Mountain Wood Products
3556 Wilhite Road
Sevierville, TN 37876-6602
(865) 453 4829
www.bushswood.com

Hofcraft
P.O. Box 72
Grand Haven, MI 49417-0072
(800) 828-0359
www.hofcraft.com

Jo C & Co.
111 Parrish Lane
Wilmington, DE 19810-3457
(302) 478-7619
www.paintersparadise.com

Viking Woodcrafts, Inc.
1317 8th Street SE
Waseca, MN 56093
(800) 328-0116
www.vikingwoodcrafts.com

Wayne's Woodenware
102C Fieldcrest Drive
Neenah, WI 54956
(800) 840-1497
www.wayneswoodenware.com

RETAILERS IN CANADA

Crafts Canada
2745 Twenty-ninth St. NE
Calgary, Alberta T1Y 7B5

Folk Art Enterprises
P.O. Box 1088
Ridgetown, Ontario N0P 2C0
(888) 214-0062

MacPherson Craft Wholesale
83 Queen St. E.
P.O. Box 1870
St. Mary's, Ontario N4X 1C2
(519) 284-1741

Maureen McNaughton Enterprises
RR #2
Belwood, Ontario N0B 1J0
(519) 843-5648

Mercury Art & Craft Supershop
332 Wellington St.
London, Ontario N6C 4P7
(519) 434-1636

Town & Country Folk Art Supplies
93 Green Lane
Thornhill, Ontario L3T 6K6
(905) 882-0199

RETAILERS IN THE UNITED KINGDOM

Crafts World
No 8 North Street
Guildford
Surrey GU1 4AF
Tel: 07000 757070

Chroma Colour Products
Unit 5 Pilton Estate
Pitlake
Croydon CR0 3RA
Tel: 020 8688 1991
www.chromacolour.com

Green & Stone
259 King's Road
London SW3 5EL
Tel: 020 7352 0837
greenandstone@enterprise.net

Hobbycrafts
River Court
Southern Sector
Bournemouth International
Airport
Christchurch
Dorset BH23 6SE
Tel: 0800 272387

Homecrafts Direct
P.O. Box 38
Leicester LE1 9BU
Tel: 0116 251 3139

Index

Explore a world of decorative painting possibilities with North Light Books!

Joy to the World

Learn to paint your favorite Christmas themes, including Santas, angels, elves and more, on everything from glittering ornaments to festive albums. Renowned decorative painter John Gutcher shows you how with 9 all-new, step-by-step projects. He makes mastering tricky details simple with special tips for painting fur, hair, richly textured clothing and realistic flesh tones.

ISBN 1-58180-105-X, paperback, 128 pages, #31794-K

Painting Gilded Florals and Fruits

Learn how to enhance your paintings with the classic elegance of decorative gold, silver and variegated accents. Rebecca Baer illustrates detailed gilding techniques with step-by-step photos and invaluable problem-solving advice. Perfect for your home or gift giving, there are 13 exciting projects in all, each one enhanced with lustrous leafing effects.

ISBN 1-58180-261-7, paperback, 144 pages, #32126-K

Decorative Mini-Murals

Add drama to any room in your home with one of these 11 delightful mini-murals! They're perfect for when you don't have the time or the experience to tackle a whole wall. You'll learn which colors and brushes to use, plus tips and mini-demos for getting the realistic effects you love. Includes detailed templates, photos and step-by-step instructions.

ISBN 1-58180-145-9, paperback, 144 pages, #31891-K

Color for the Decorative Painter

This guide makes using color simple. Best of all, it's as fun as it is instructional, featuring ten step-by-step projects that illustrate color principles in action. As you paint your favorite subjects, you'll learn how to make color work for you. No second-guessing, no regrets-just great-looking paintings and a whole lot of pleasure.

ISBN 1-58180-048-7, paperback, 128 pages, #31796-K

These books and other fine North Light tiles are available from your local art & craft retailer, bookstore, online supplier or by calling 1-800-448-0915